P9-CNB-746

THE HUMAN MACHINE

THE ANATOMICAL STRUCTURE &
MECHANISM OF THE HUMAN BODY

THE HUMAN MACHINE

THE ANATOMICAL STRUCTURE & MECHANISM OF THE HUMAN BODY

By GEORGE B. BRIDGMAN

INSTRUCTOR, LECTURER ART STUDENTS LEAGUE NEW YORK, AUTHOR: THE BOOK OF ONE HUNDRED HANDS ⁄ HEADS, FEATURES AND FACES ⁄ LIFE DRAWING CONSTRUCTIVE ANATOMY

DOVER PUBLICATIONS, INC.

NEW YORK

This Dover edition, first published in 1972, is an
unabridged republication of the work originally
published by Bridgman Publishers, Inc., in 1939.
The work is reprinted by special arrangement with
Sterling Publishing Company, 419 Park Avenue
South, New York City 10016.

International Standard Book Number: 0-486-22707-3
Library of Congress Catalog Card Number: 70-187018

Manufactured in the United States of America
Dover Publications, Inc.
180 Varick Street
New York, N. Y. 10014

Dedicated
To Louise

INTRODUCTION

IT APPEARS to be a fixed law that the contraction of a muscle shall be towards its centre, therefore, the subject for mechanism on each occasion is so to modify the figure, and adjust the position of the muscle as to produce the motion required agreeably with this law. This can only be done by giving to different muscles a diversity of configuration suited to their several offices and to their situation with respect to the work which they have to perform. On which account we find them under a multiplicity of forms and altitudes; sometimes with double, sometimes with treble tendons; sometimes with none, sometimes with one tendon to several muscles; at other times with one muscle to several tendons. The shape of the organ is susceptible of an incalculable variety, while the original property of the muscle. The law and line of its contraction remains the same and is simple. Herein the muscular system may be said to bear a perfect resemblance to our works of art. An artist does not alter the native quality of his materials or their laws of action. He takes these as he finds them. His skill and ingenuity are employed in turning them such as they are, to his account by giving to the parts of his machine a form and relation in which these unalterable properties may operate to the production of the effects intended.

Palley's Theology.

TABLE OF CONTENTS

SKULLS

1— FRONTAL IN FRONT

2—OCCEPITAL BACK OF HEAD

3—TEMPORAL TEMPUS
 TIME TEMPLE

4— MALAR CHEEK BONE

5— INFERIOR LOWER
 MAXILLARY JAW BONE

FACIAL MUSCLES

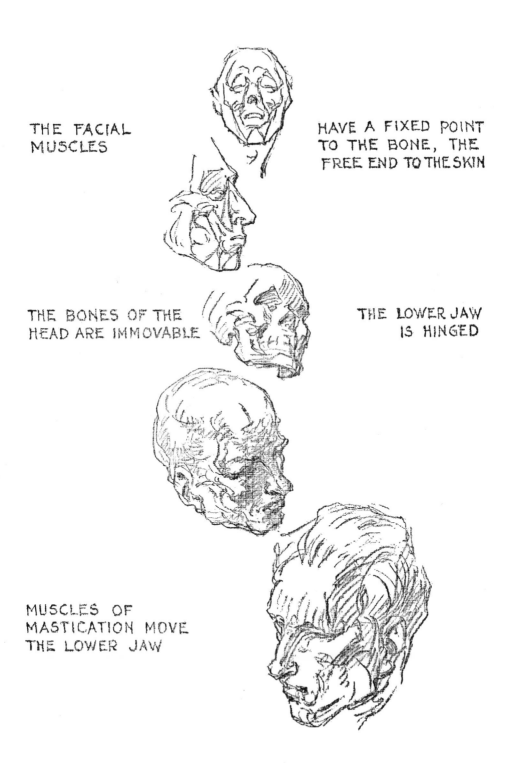

THE FACIAL
MUSCLES

HAVE A FIXED POINT
TO THE BONE, THE
FREE END TO THE SKIN

THE BONES OF THE
HEAD ARE IMMOVABLE

THE LOWER JAW
IS HINGED

MUSCLES OF
MASTICATION MOVE
THE LOWER JAW

PLANES

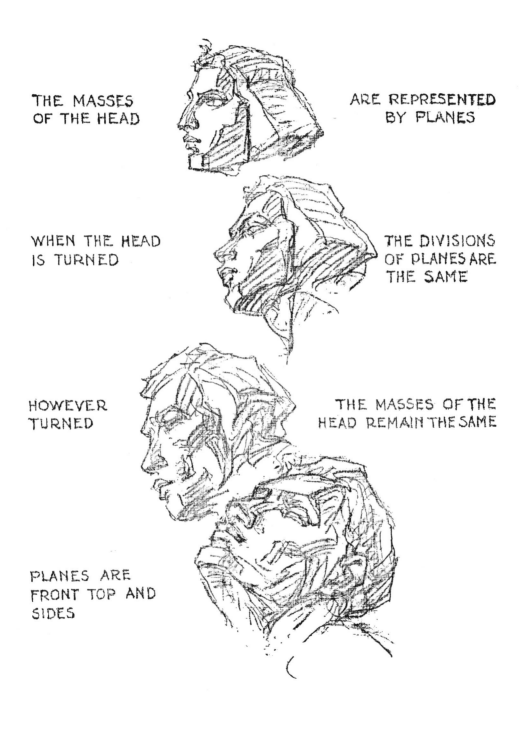

THE MASSES
OF THE HEAD

ARE REPRESENTED
BY PLANES

WHEN THE HEAD
IS TURNED

THE DIVISIONS
OF PLANES ARE
THE SAME

HOWEVER
TURNED

THE MASSES OF THE
HEAD REMAIN THE SAME

PLANES ARE
FRONT TOP AND
SIDES

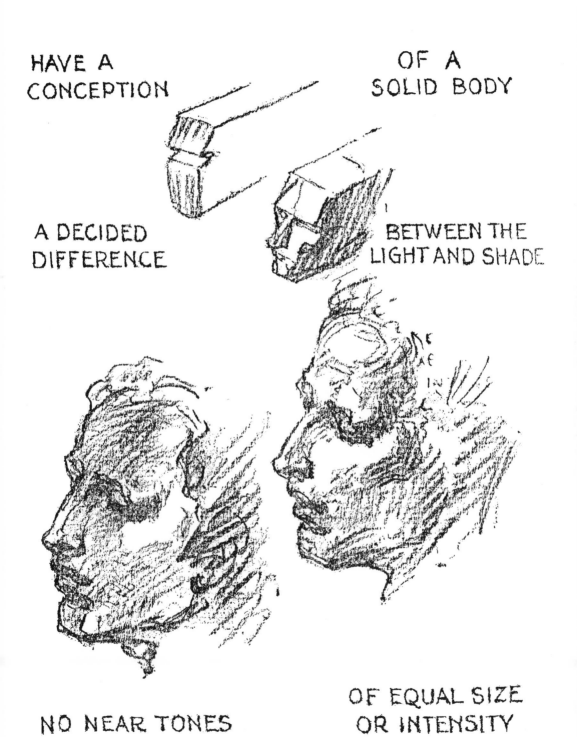

HAVE A
CONCEPTION

OF A
SOLID BODY

A DECIDED
DIFFERENCE

BETWEEN THE
LIGHT AND SHADE

NO NEAR TONES

OF EQUAL SIZE
OR INTENSITY

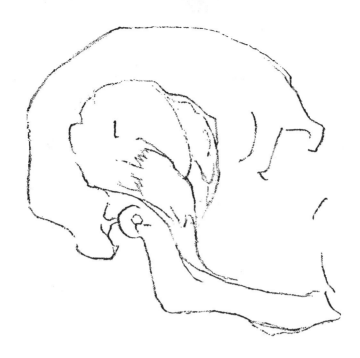

THE TEMPORAL MUSCLE

The mouth was made to cut and grind food. To save this trouble and work, mechanical devices such as the millstone were put into operation. Here the upper stone ground while the lower was stationary. In the human machine, the upper stone is fixed and the lower does the grinding. The only movable bone of the skull is the lower jaw which hinges to the head just in front of the ear. It acts as a lever of the third order. The cutting and grinding force is controlled by powerful muscles. The one that raises the lower jaw is named

1....The temporal muscle; attached to the coronoid portion of lower jaw it passes upward under the zygomatic arch covering the temporal fossa. From its attachment above, its fibres converge before passing under the arch.

2....Inferior maxillary — lower jaw.

3....Zygomatic arch.

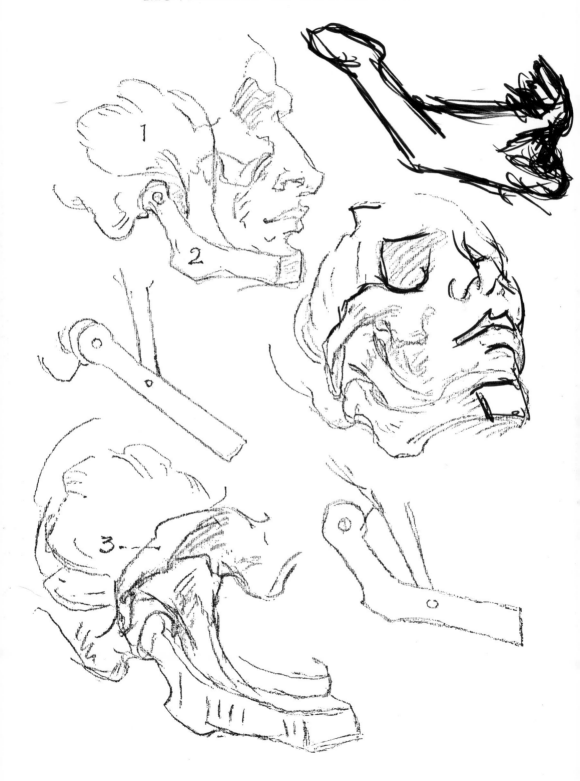

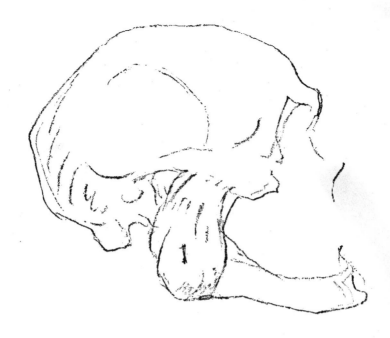

THE MASSETER

The inferior maxillary or lower jaw bone is shaped somewhat like a horse-shoe. Its front projection forms the chin; it then passes backward on either side of the mouth then bends upwards ending in a head or condyle that articulates with the temporal bone.

1....The masseter muscle. The muscles of mastication are of marked prominence and are called masseters. They move the lower jaw and are inserted into the vertical branch of the lower jaw-bone; the upper part or the superior border arises from the zygomatic arch. By its contraction it brings the teeth together in cutting and grinding. Unlike the facial muscles or muscles of expression, the temporal and the masseter extend from the surface of one bone to that of another, that is, from the unmovable bones of the head to the movable lower jaw-bone.

In the human species, the mouth not only is used for the grinding and breaking down of food, but also the respiration of air and the utterance of sound.

LOWER JAW BONE

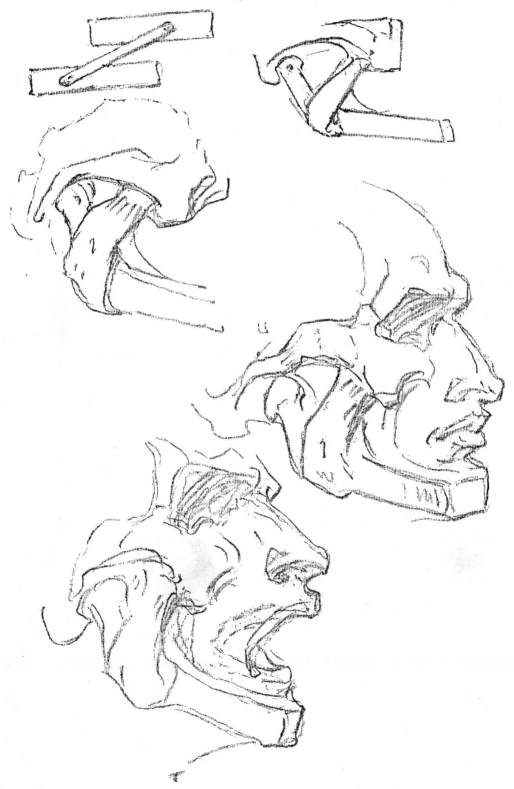

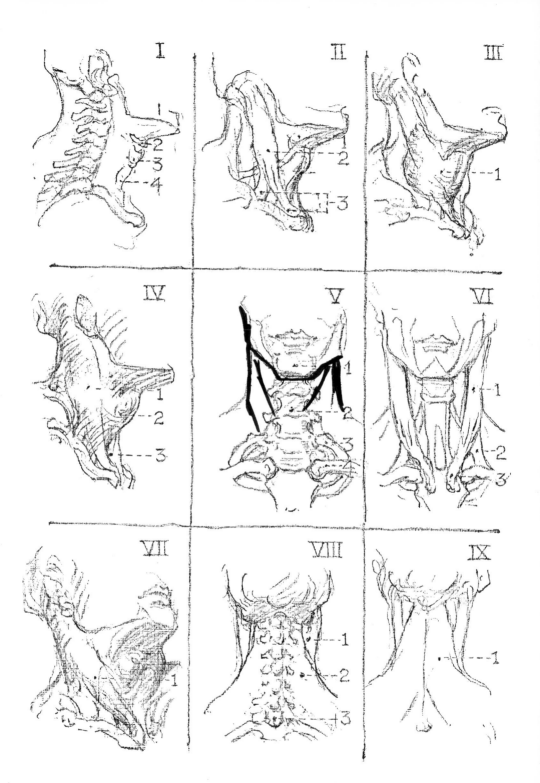

THE NECK

I

1....The inferior maxillary or lower jaw bone.
2....The hyoid or tongue bone.
3....The thyroid cartilage or Adam's apple.
4....Trachea or wind pipe.

II

1....The canopy under the chin.
2....The sterno-mastoid.
3....Attachment to clavicle and the attachment to the sternum of the sterno-cleido-mastoid muscle, the attachment of this muscle above is directly back of the ear.

III

1....The neck in shape is a rounded cylinder that follows the direction of the spine.

IV

1....The column of the neck curves slightly forward even when the head is thrown back.
2....Adam's apple.
3....Pit of the neck.

V

1....The mentum or chin.
2....Cervical vertebrae.
3....First rib.
4....Clavicle or collar bone.

VI

1....Sterno-mastoid.
2....Showing its attachment to the clavicle.
3....And to the sternum.

VII

The sterno-cleido-mastoid turns the head from side to side towards the shoulder when both muscles act together; they depress the face downward.

VIII

1....Sterno-cleido mastoidus muscle.
2....The trapezius; to the skull at the curved line of the occipital bone. Its fibres are carried obliquely downward and outward.
3....The seventh cervical vertebrae, a prominent projection at the back of the neck.

IX

1....The region at the back of the neck is somewhat flattened and much shorter than in front. The head represents the weight to be moved; the muscles, the power to make the movement of the head upon the neck possible.

[15]

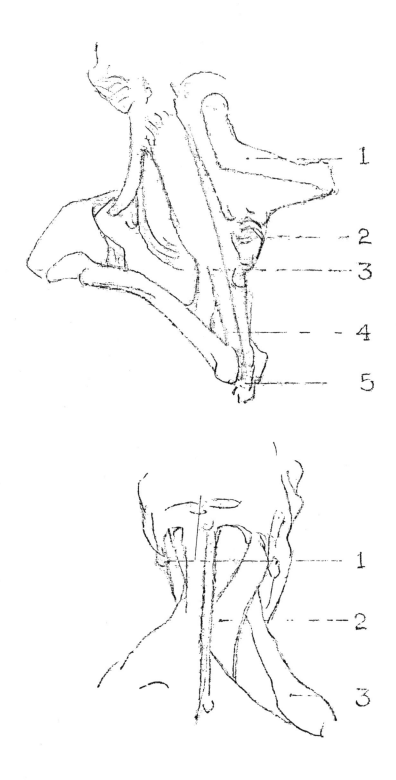

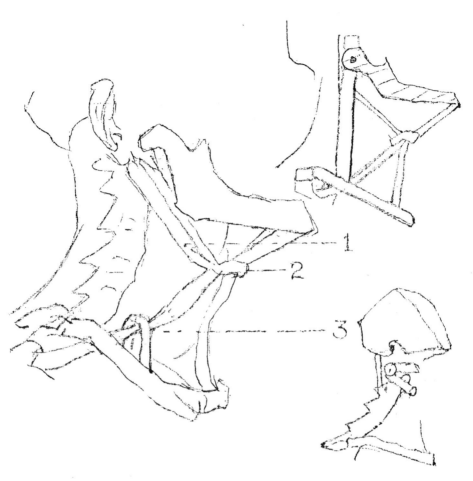

NECK........SIDE VIEW
 1....The lower jaw.
 2....The larynx or Adams Apple.
 3....The sterno-cleido-mastoid. (sternum, the breast bone)
 4....The clavicle, collar bone.
 5....The sternum, breast bone.
NECK FROM THE BACK
 1....The sterno-cleido-mastoid.
 2....The splenius capitus.
 3....The levator of the scapula, (shoulder blade).
THROAT MUSCLES
 1....Digastric.
 2....Hyoid bone.
 3....Omo-hyoid, passes through pulley.

The neck is cylindrical in shape; it follows the curve of the spinal column. Two curves follow the form of the cylinder. One downward follows the fullness of the neck, and then turns outward toward the outer third of the collarbone, and the second curve encircles the rounded form from the back of the neck downward toward the pit in the same manner that a string of beads drop downward, as they follow the rounded contour. The neck rises as a column curving slightly forward even when the head is thrown well back. It is rooted at the chest and canopied above by the chin. It is somewhat flattened at the back where the back of the head overhangs. The neck is buttressed on each side by the shoulders. Behind each ear bands of muscle descend towards the root of the neck. These muscles almost meet a hollowed out point at the pit.

1....For safety as well as to see and to hear, the head and shoulders must be able to turn in all directions.

2....The head is a lever of the first order.

3....The muscles that move the atlas.

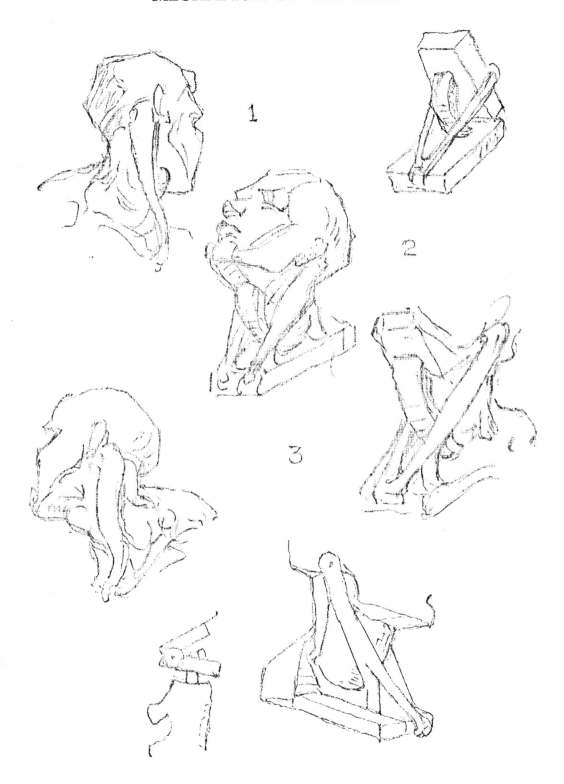

THE HAND

FLEXION

BENDING
THE FINGERS

EXTENSION

STRAIGHTENING
THE FINGERS

ADDUCTION
TOWARD
RADIAL SIDE

ABDUCTION
ULNAR SIDE

PROPORTIONS OF THE FIRST FINGER
SIDE VIEW

FLECTION AND EXTENSION

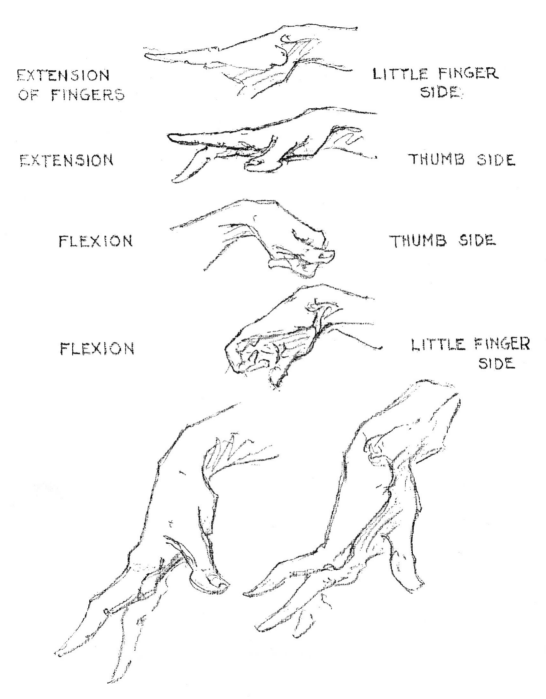

EXTENSION
OF FINGERS

LITTLE FINGER
SIDE

EXTENSION

THUMB SIDE

FLEXION

THUMB SIDE

FLEXION

LITTLE FINGER
SIDE

EXTENSION

THUMB SIDE

LITTLE FINGER SIDE

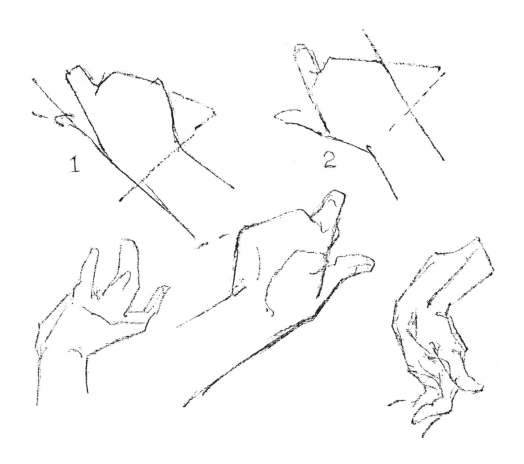

THE HAND CONSTRUCTION

1....Thumb side, the straight or inaction side;

2....Thumb side is now the action side;

In the hand as in the human figure, there is an action and inaction side. The side with the greater angle at the wrist is the action side; the opposite is the inaction or straight side. The back of the hand, when bent toward the body at the wrist makes the thumb side the action side, and the little finger side the inaction or straight side. Again seeing the hand from the back and drawn away from the body, the thumb side then becomes the inaction side and the little finger the angular or action side. Seen from the palmar side, the action and inaction movements are reversed. This can easily be observed by passing a stick or ruler down the forearm and bending the hand till one side or the other lines up straight with the ruler. From the thumb side the inaction line ends at the base of the thumb.

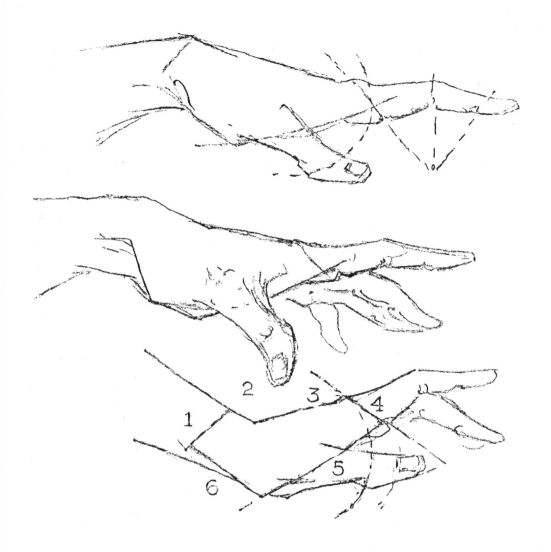

SIDE VIEW
CONSTRUCTION OF THE HAND

Showing the construction lines of the wrist and hand.

1....Line marking where the forearm joins wrist.
2....Where the wrist joins the back of hand.
3....From back of hand to the knuckle.
4....From knuckle to second metacarpal bone where the palm and the finger pad meet.
5....From where palm and finger meet to base of thumb.
6....From the base of thumb to where arm and wrist meet.

[23]

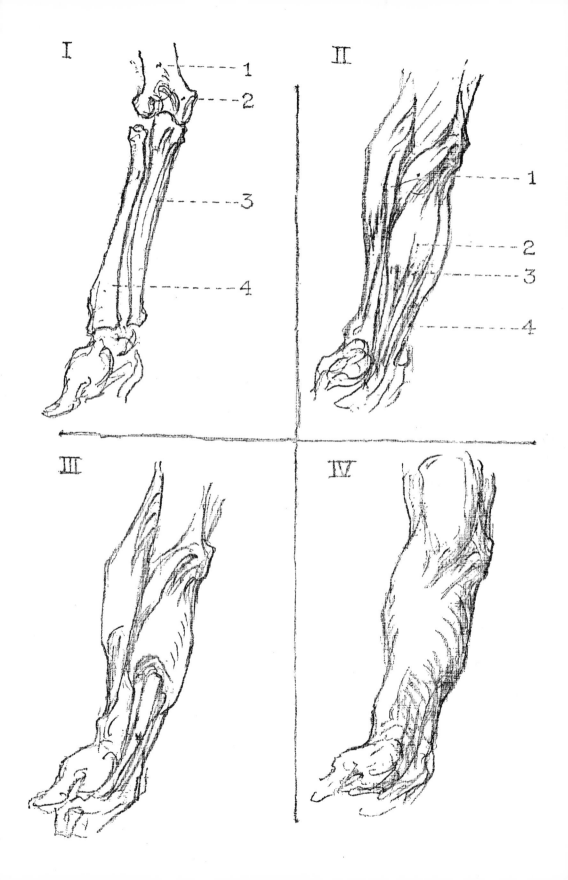

BONES: I

1. The upper arm bone the humer-us, is the longest bone of the upper limb. It is composed of a shaft and two extremities.

2. At the lower end of the humerus there are two projections. The inner projection (the inner condyle) is quite prominent and always in evidence and is used as a point of measurement.

3. The forearm is composed of two bones, the radius and the ulna. The ulna hinges at the elbow, it articu-lates with the bone above by a beak like process and descends toward the little finger side of the hand, where it is seen as a knob like eminence at the wrist.

4. The radius carries the thumb side of the wrist and hand at its lower extremity. At the upper end, the head is hollowed out to play freely on the radial head of the humerus.

MUSCLES: II

1. The pronator teres. From its origin on the internal condyle of the humerus is directed downward and outward and inserted into the outside of the radius about half way down the shaft. In contraction it turns the forearm and thumb side of the hand inward causing pronation.

2. There are four flexor muscles that arise from the internal condyle of the humerus, their bodies are most-ly fleshy terminating at their lower half in long tendons.

3. The palmaris longus, also a flex-or, shows a long slender tendon di-rected toward the middle of the wrist. It is inserted into the palmaris facia that stretches across the palm of the hand.

4. Flexor carpi ulnaris.

III

Muscles must lie above and below the joint they move. Muscles that bulge the forearm in front are flexors, they terminate as wires or strings that pull the wrist, hand and fingers to-gether as they contract.

IV

The inner condyle of the humerus is a landmark when the forearm is seen from the front and the bones are par-allel. In this position, the muscles and their tendons are directed downward to the wrist and hand.

The first, the pronator teres, passes obliquely to the middle of the radius. The second, the flexor carpi, radiates toward the outer side of the hand. The third, the palmaris longus, is toward the middle and the fourth. The flexor carpi ulnaris is toward the inner border of the hand. The muscles just named are situated on the front and inner side of the forearm and all arise from the inner condyle of the humerus.

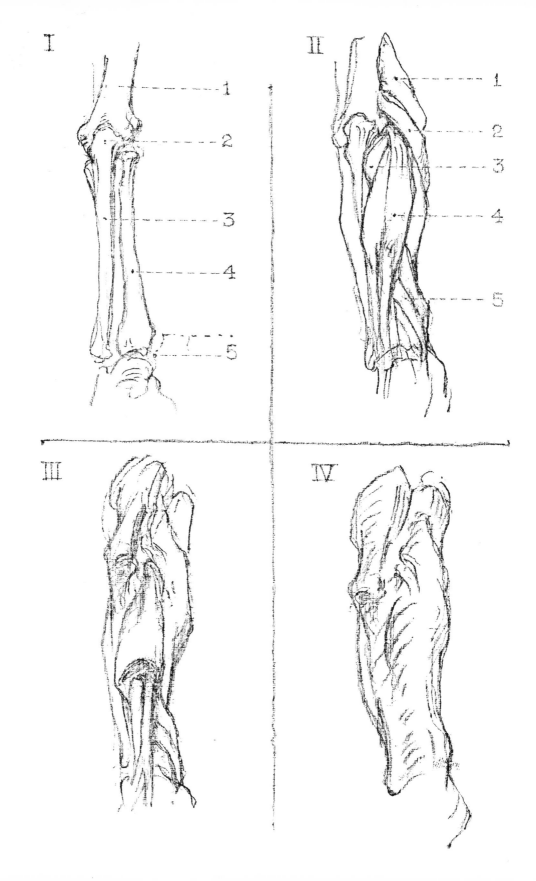

I

1
2

3

4

5

II

1

2

3

4

5

III

IV

FOREARM . . . BACK VIEW

BONES: I

1. The humerus of the arm presents a shaft and two extremities.

2. Olecranon process of the ulna, elbow.

3. The ulna, from the elbow to the little finger side of wrist.

4. Radius, the thumb side of the forearm at the wrist.

5. The styloid process of the radius.

MUSCLES: II

1. The supinator longus arises from the outer border of the humerus to about a third of the way up its shaft. It then enlarges as it descends to its greatest size at about the level of the external condyle, below its fibres are replaced by a long tendon that is inserted into the styloid process of the radius.

2. On the humerus, just below the supinator, arises the long extensor of the wrist. This muscle descends by a slendor tendon to the index finger and is named the extensor carpi radialis longior.

3. Anconeus, a small triangular muscle attached to the external condyle of the humerus and inserted into the ulna just below the elbow.

4. There are four extensors including the long extensor of the wrist just mentioned. Three of these arise from the external condyle of the humerus, descend as muscles about half way down and end as tendons that extend the wrist, the hand and the fingers.

The fourth arises from the shaft of the humerus just above the external condyle.

5. Extensors of the thumb.

III

The muscles of the forearm are placed just below the elbow, moving the hand, the wrist and fingers by long slim tendons that are securely strapped down as they pass under or over the wrist. It is a fixed law that a muscle contracts toward its center. Its quickness and precision of movement depends upon its length and bulk. If the muscles of the forearm had been placed lower down, the beauty of the arm would have been destroyed.

IV

The muscles that lie on the outer side and back of the forearm are known as the supinator and the extensor group. They emerge from between the biceps and the triceps at about a third of the distance up the arm as a fleshy mass. These wedge shaped muscles are placed on a higher level than the pronator or flexor group, as they arise some distance above the outer condyle of the humerus. The extensor group take their origin from the condyle below. The extensor tendons are on the back of the arm and always point to the outer condyle of the humerus. The extensor muscles are the direct antagonists of the pronators and flexors in front. The chief action of the supinator longus is that of a flexor but acts as in supination as well.

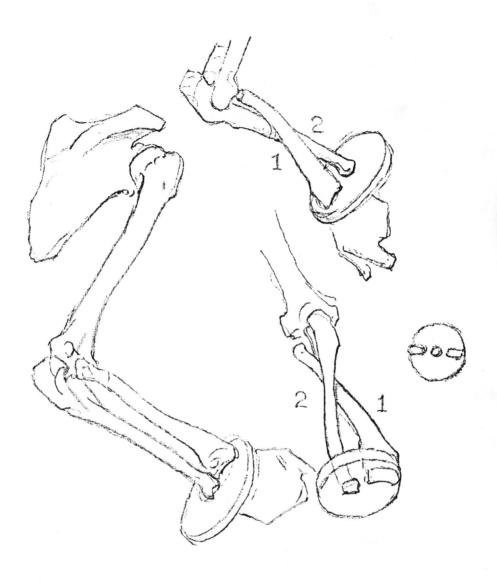

1..RADIUS 2..ULNA

The radius is on the thumb side of the hand at the wrist. It operates in a wheel-like motion. This bone is twisted obliquely and moves circularly around round the head of the ulna. The radius circles around the little finger side of the hand in both supination and pronation, making the head of the ulna at the wrist the axis around which the radius follows the rim of a supposed wheel.

The variety, quickness and precision of which the arm and hand are capable is even at times beyond conception. The head of the radius turns on its own axis at the radical head, but does not change its position next the ulna, due to a ring of ligament that keeps it close to a hollowed out surface of the ulna. This is called the radial notch

FOREARM

The mechanical contrivance of the forearm

The forearm is the lower arm from the elbow to the wrist. It is joined to the bone above at the elbow. For the movement of the limb two motions are required. The swinging of the forearm backward and forward and a rotary motion by which the hand can be turned with the thumb outward or the thumb inward toward the body. The forearm consists of two bones that lie along side each other. Only one of these bones is joined to the upper part of the arm at the elbow as a hinge joint. This allows a movement in one plane, as it swings backward and forward, it carries along with it the other bone and the whole forearm. When the palm of the hand is turned upward, the other bone to which the hand is attached, rolls upon the first. These two bones of the forearm are called the radius and the ulna.

The joints are lubricated to make them slip easily one upon the other. They are sealed by a capsule and held together by strong braces to keep them in position. Strings and wires, that is, muscles and their tendons are then inserted for the purpose of drawing the bones in the direction in which the joints allow them to move. The radius alone carries the hand. The thumb side of the hand when turned out or in toward the body is in the same position as the two bones of the forearm. Parallel when the thumb is turned out, crossing one another when the thumb is turned in. The radius moves wheel-like around the ulna. The forearm is pivoted or jointed at the elbow which becomes its fulcrum. At the end of this lever is the hand. To flex the forearm the power is placed in the arm above and attached to the forearm below. The muscular power is placed so close to the hinge-like joint that it lacks in power, but has the advantage of speed. Whatever is lost in strength is gained in quickened action.

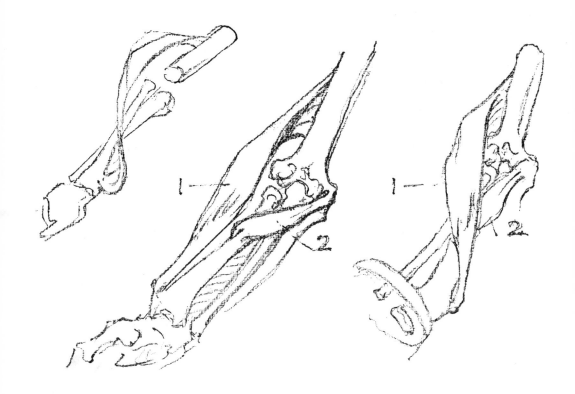

PRONATOR SUPINATOR

The two muscular forces that rotate or turn the forearm by crossing one bone over the other, are the supinator and the pronator.

1....The supinator extends from about a third way up the bone of the upper arm to the wrist. It is a long muscle. The lower third is tendinous. It rises above the outer condyle of the humerus. The upper portion is the large fleshy mass that lies on the outer and upper third of the forearm. In action it flexes as well as supinates.

2....The opposing muscle to the supinator is the short round pronator teres, which passes obliquely downward across the forearm. It arises from the inner condyle of the humerus to be inserted near the middle of the outer border of the radius. These two muscles pull the radius with a wheel-like motion over the ulna and back again carrying the thumb side of the hand toward or away from the body. The supinator is the force that turns the door-knob and the screw-driver away from the body. It is the only flexor of the forearm that can be seen on the surface of its entire length.

PRONATOR
SUPINATOR

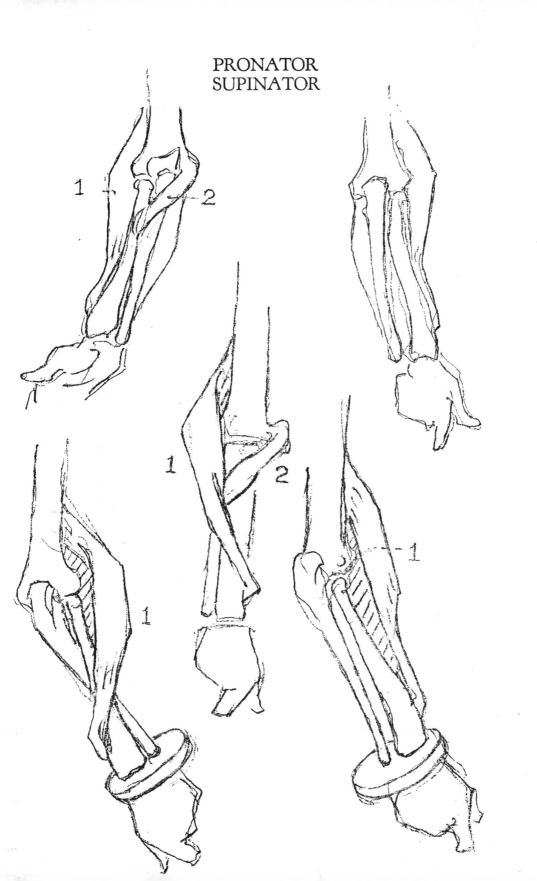

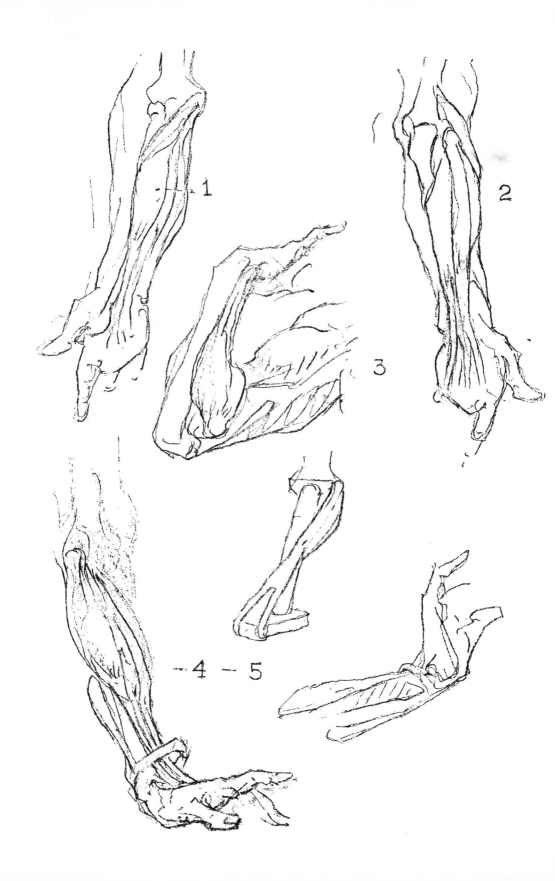

FOREARM

The muscles of the forearm move the wrist, the hand and fingers. They are muscular above and tendinous below. These tendons are strapped down to pass over and under the wrist and fingers. There is a great variety of formation and shape to the muscles of the forearm. They must be adjusted to the position they occupy and yet produce the motion required.

In the forearm there are muscles with tendons that are single and again double as they pass to the wrist and hand. The muscles of the forearm act separately or in groups with quickness and precision as the occasion requires.

1. The front and inner side of the forearm is composed of muscles that arise from the internal condyle of the humerus by common tendons and terminate below by tendons that are two-thirds the length of the muscle. These tendons separate to be inserted into the wrist and fingers and are known as flexors.

2. The muscles of the back and outer side of the forearm as a group arise from the external condyle and adjacent ridge of the humerus. As a mass it is on a higher level than that of the inner side of the forearm. As to these muscles in general: they pass down the back of the forearm and divide into tendons as they approach the wrist where they are held in place by a band called the annular wrist ligament.

3. When the arm is bent to a right angle and the hand is directed toward the shoulder, the flexor muscles are set in motion by contraction. They swell to their muscular centers and their tendons pull the hand downward. When the hand is bent at the wrist in the direction toward the front of the forearm, it is flection. The reverse is called extension.

4. The extension of the hand on the forearm showing the muscles and the tendons lying on the outer side and back of the forearm. They are held in place by the annular ligament.

The rounded forearm is made up of the fleshy bodies of muscle that terminate mostly in long tendons that pass to and over the wrist and hand. Some of these muscles move the hand on the forearm or the different finger joints on each other. There are also deep muscles of the forearm from which the tendons emerge but the muscles are hidden.

I

1
2

3

4

II

1

3

1

2

3

III

IV

I

BONES:

1. The coracoid process is a part of the shoulder blade that extends beyond and above the rim of the cup that holds the head of the arm bone, the humerus.

2. The head of the humerus is rounded and covered with cartilage, it contacts with the glenoid cavity of the shoulder blade.

3. The humerus is one of the long bones of the body. It is composed of a shaft and two large extremities; the upper articulates at the shoulder and the lower at the elbow.

4. The shaft of the humerus at the elbow is flattened from front to back ending in two projections; one on the inner, the other on the outer side, and are called the inner and outer condyles. The inner side is the most prominent.

II

MUSCLES:

1. The coraco-brachialis is a small round muscle placed on the inner surface of the arm lying next to the short head of the biceps.

2. The biceps, so called, because it is divided into two parts; the long and the short. The long head ascends in the bicipital groove of the humerus to be inserted just above the upper margin of the glenoid cavity of the shoulder blade. The short head has its at-tachment to the coracoid process. The biceps descend as a tendon to the radius below the elbow.

3. The brachialis anticus muscle lies beneath the biceps. It stretches across the lower half of the humerus to the ulna.

III

Both the biceps and brachialis muscles are placed in front of the arm. When they contract they bend the elbow. Every muscle is provided with an adversary, as an example: the finger is not bent or straightened without the contraction of two muscles taking place. The biceps and brachialis anticus are the direct antagonists of the triceps. The brachialis anticus muscle covers the lower half of the humerus in front and is inserted into the ulna just below the elbow. Its attachment to the ulna is so short that it is at a great disadvantage as to power, but what is lost in strength is gained in speed by its short leverage.

IV

The mass of the shoulder decends as a wedge on the outer surface of the arm halfway down. The biceps is seen as a flattened mass when not in contraction as it wedges downward to enter the forearm below the elbow. There are great changes in the form of the arm above the elbow as a mass, the biceps is lengthened in repose, but becomes short and globular during contraction.

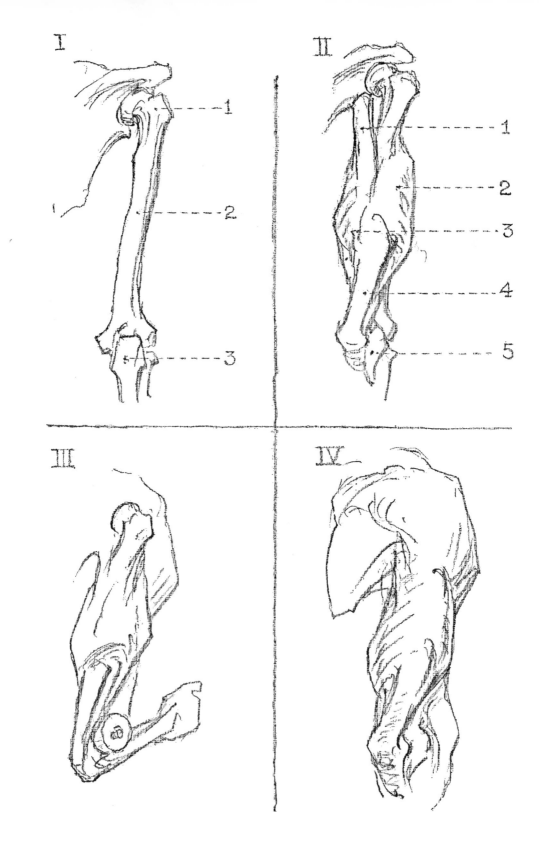

THE ARM ... BACK VIEW

BONES: I

1. The great tuberosity of the humerus is situated on the outer side of the bicipital groove. At its upper extremity it is a prominent bony point of the shoulder. Though covered by the deltoid, it materially influences the surface form.

2. The shaft of the humerus is cylindrical.

3. The olecranon of the ulna forms the point of the elbow.

MUSCLES: II

1. Longhead; 2. External portion; 3 Internal portion of the triceps; 4. Common tendon of the triceps.

The triceps muscle has been so named because it is composed of three portions or heads, one of which is central and two lateral. The long head arises from the border of the shoulder blade immediately below the glenoid cavity and terminates in a broad flat tendon, which is also the termination of the internal and external portions. The external head arises from the upper and outer part of the humerus. The inner head is also on the humerus, but on the inner side. Both muscles are attached to the common tendon, which is inserted to the olecranon process of the ulna.

5. The anconius muscle, small and triangular in shape is attached in the external condyle of the humerus above, and below to the ulna, a continuation of the triceps.

III

Muscles act only by contraction. When exertion ceases they relax. The muscles that are placed on the front part of the arm, by their contraction bend the elbow; to extend and straighten the limb. The triceps (the opposing muscle), is brought into play with no less than that which bent it. The elbow joint that these muscles move is a hinge joint that moves in one plane only either forward or backward.

IV

The back of the arm is covered by the large muscular form of the triceps, which extends the entire length of the humerus. This muscle is narrow above, widening below to the furrow of the outer head of the triceps. From here the common tendon of the triceps follows the humerus as a flattened plane to the olecranon process of the ulna. The common tendon of the trices receives the muscular fibres from all three heads of the trices. The direction of this broad flat tendon is in line with the humerus.

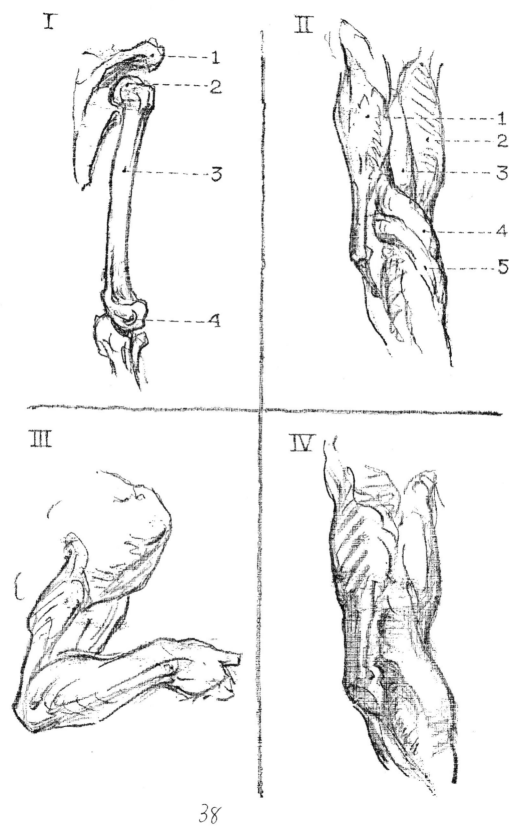

I

1 ----
2 ----
3 ----
4 ----

II

1 ----
2 ----
3 ----
4 ----
5 ----

III

IV

38

BONES: I

1. Acromion process of the shoulder blade.
2. Head of the humerus.
3. Shaft of the humerus.
4. The external condyle.

MUSCLES: II

1. The triceps is a three headed muscle. By contraction, it extends the forearm.
2. The biceps is a two headed muscle. By contraction, it depresses the shoulder blade, flexes the forearm and rotates the radius outward.
3. Brachialis anticus: (brachialis, pertaining to arm; anticus, in front). By contraction, it flexes the forearm.
4. Supinator longus.
5. Extensor carpi radialis longus; extensor, (extender); carpi, (carpus, the wrist); radialis, (radiates); longus, (long), is responsible for the action that extends the wrist.

III

Muscles with their tendons are the instruments of motion as much as the wires and strings that give the movements to a puppet. In the upper arm, the wires that raise or lower the forearm are placed in directions which parallel the bones. All the muscles of the body are in opposing pairs. When a muscle pulls, the opposing one yields with just sufficient resistance to balance the one that is pulling. The forearm is the lever on which both the biceps and the triceps flex and straighten out the arm at the elbow. The muslces just mentioned parallel the arm to swing the forearm backward and forward.

Another contrivance is needed to give rotary motion to the thumb side of the hand. In order to do this, the power is attached to the lower third of the humerus above the outer condyle and extends to near the end of the radius at the wrist. It is this muscle that aids in turning the door-knob and the screwdriver.

IV

In looking at the arm from the outer side it is seen that the deltoid descends as a wedge sinking into an outer groove of the arm. The mass of the biceps and triceps lie on either side. There is as well an outer wedge, the supinator longus. These different forms denote entirely different functions. Mechanism has always in view, one of two purposes; either to move a great weight slowly, or a lighter weight with speed. The wedge at the shoulder creates power. Lower down on the arm, speed. This mechanism allows the wrist and hand to move up and down as well as circularly, with a certain firmness and flexibility compared to the comparatively slow motion of which the arm can be raised.

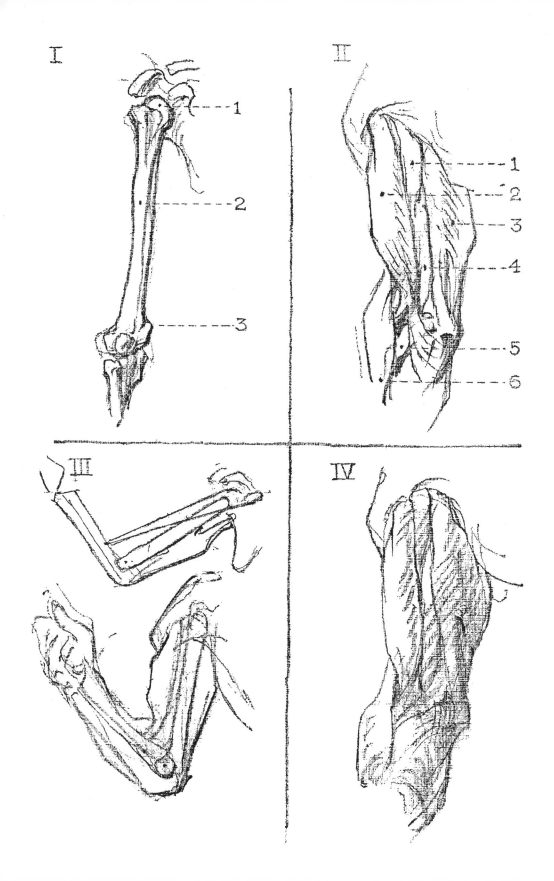

I

1

2

3

II

1

2

3

4

5

6

III

IV

BONES: I

1. The bone of the upper arm is called the humerus. It consists of a long strong cylinder. As it is not flexible, it can turn only on joints, one at the shoulder to raise the arm and one at the elbow to bend it. The upper extremity seen from the inner side consists of a round smooth ball that is covered over by a layer of cartilage and is known as the head of the humerus. It glides in the cup shaped cavity of the shoulder blade, the glenoid cavity.

2. The cylindrical shaft of the humerus.

3. The inner condyle of the humerus is larger and more prominent than the outer one. It is the origin of the flexors of the forearm as well as a muscle that pulls the thumb side of the forearm toward the body, the pronator teres.

MUSCLES: II

1. Coraco-brachialis: from coracoid process to humerus, inner side half way down. Its action: it draws forward and rotates the humerus outward.

2. Biceps: the long head from upper margin of the glenoid cavity, the short head from coracoid process to radius. Its action: it flexes the forearm and rotates the radius outward.

3. Triceps: the middle or long head; the external head; the internal or short head. Its action: it extends the forearm.

4. Brachialis anticus: from front of the humerus and the lower half to the ulna. Its action: it flexes the forearm.

5. Pronator radius teres: extends from the internal condyle to the radius on the outer side and halfway down. Its action: it pronates the hand and flexes the forearm.

6. Supinator longus: the external condyloid ridge of the humerus to the end of the radius. Its action is to supinate the forearm.

III

The arm and forearm is pivoted or jointed at the elbow. The elbow is the fulcrum. The power that moves the lever is a muscular engine. When the forearm is raised the power is exerted by the biceps and brachialis anticus, when this action takes place, the triceps are inert.

IV

The arm, seen from the inner side presents the greatest width at the fleshy region of the deltoid, two-thirds of the way from above the elbow, then diminishes as a hollow groove, bordored by its common tendon. The inner view of the arm, the side that lies next the body, has a number of muscles that point this way and that way, as well as up and down, to pull and draw the joint in the direction to which it is attached. The crossing at different angles braces the arm as well as allows great freedom of movement.

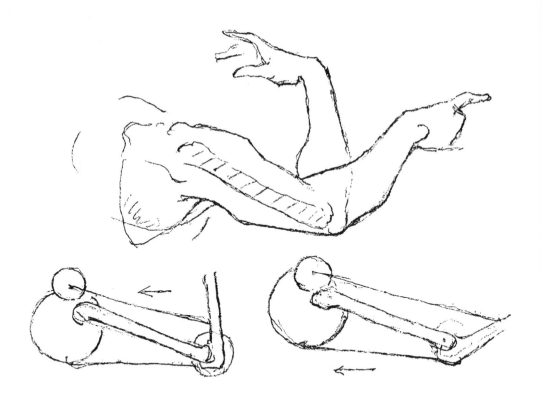

ARM AND FOREARM

The arm plays in a socket at the shoulder and swings on a hinge at the elbow. The rounded head of the arm bone fits into the cupped cavity of the shoulder blade, where a short, flexible ligament is attached to the head of the ball and is inserted into the bottom of the cup keeping the two parts firmly in their place. Around the edges of both cup and ball a membrane is tied. This confines and holds the bones together. The elbow is surrounded as well by a strong and firm parchment-like membrane, which keeps the parts from further action than they are allowed to go in the plane of their motion. In all joints, the opposing bones are coated with cartilage, which by pressure are oiled by the breaking down of the cartilage itself and is called the lubricating system.

A mechanical contrivance is seen at its best in the forearm for the perfect use of the limb where three movements are required, a backward and forward, as well as, a rotary motion.

By comparing the mechanism at the shoulders with the same at the elbow, it is seen that there are laws that control each separate joint. The ball and socket at the shoulders and the tendons and membranes have already been mentioned. The surrounding ligaments are loose enough to allow a free motion of flexion and extention. The round ligament, that is inserted into the head of the humerus and into the cup of the shoulder blade, is also flexible and still taut enough to keep the two parts firmly in their places.

The shape of the lower extremity of the humerus gives the key to the elbow joint. It is flattened out from front to the back, and at the sides there are projections. These projections, the inner and outer condyles, have pully-like grooves around which the upper extremities of the forearm articulate.

The ligaments which surround the elbow are stronger on the sides than front and back, so that the joint cannot slip sideways or go further than they ought to in their place of motion.

The two bones of the forearm are not on the same level either above or below. From above, the ulna extends beyond the head of the radius. Below, the radius extends beyond the head of the ulna and is the only bone of the forearm that articulates with the hand.

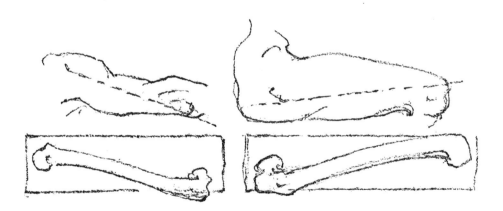

The bone of the upper arm descends diagonally downward from the shoulder to the elbow.

The thigh bone ascends diagonally upward from the pelvis to the knee.

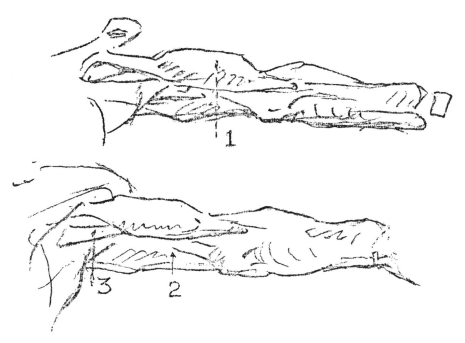

In the human body, there is a framework of bone. This frame-work is called the skelton. Muscles move this skelton. Both muscles and bones have to be named the same as the component parts of any machine is given a name that is expressive of that particular part. The muscle that is placed in front of the arm has two heads, and is therefore called the biceps. On the back is a three headed muscle called the triceps. The coraco brachialis is named from its origin on a beak-like process of the shoulder blade.

1. The biceps bends the elbow and flexes the forearm. In so doing, it becomes thicker and shorter and is a good example as to what happens to every muscular engine when set in motion. The fulcrum or base, from which it exerts its power, is the shoulder blade, where its two heads are attached. Its tendon below ends in the forearm on the radius and the forearm is the lever on which it acts.

2. The triceps muscle is situated on the back of the arm. It extends the entire length of the humerus and is divided into three parts. Its outer head occupies the outer and upper surface of the humerus. The inner head occupies the inner and lower portion of the bone. The long head reaches diagonally in and up to the shoulder blade. Following the bone of the upper arm, is a flattened space, which marks its common tendon. This muscle with its tendon straightens out the flexed arm and is the antagonist to the biceps.

3. The coraco brachialis.

[44]

BICEPS TRICEPS

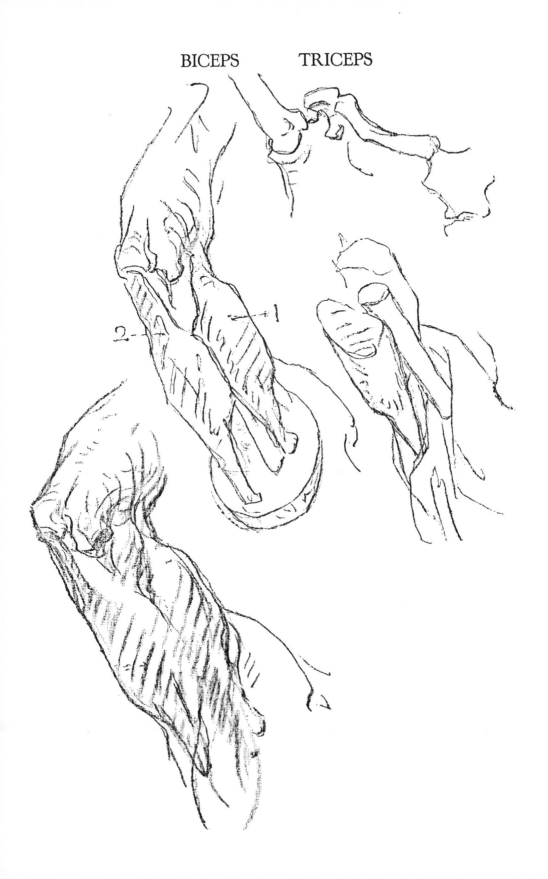

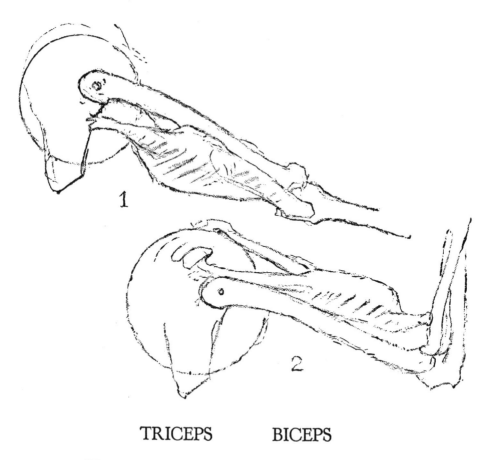

TRICEPS BICEPS

1. The triceps straighten out the flexed arm.
2. The biceps bends the elbow and flexes the forearm on the arm.

A finger is not bent or straightened without the contraction of two muscles taking place. A muscle acts only by contraction. In the same way a finger is bent, the forearm is bent. The muscles on the front part of the arm by their contraction, bend the elbow, those on the back extend and straighten the arm. The lever of the forearm is pivoted or jointed at the elbow which acts as its fulcrum. To straighten the arm, the heavy three-headed triceps play against its antagonist, the two-headed biceps. When the exertion of either of these two muscles cease, they relax to their former state.

The arm consists of a strong cylinder of bone which turns on the joint at the shoulder to raise the arm, and another joint at the elbow to bend it. These joints are made to slip on one another and are pulled as they contract or relax, thus changing the surface forms while undergoing action or relaxation.

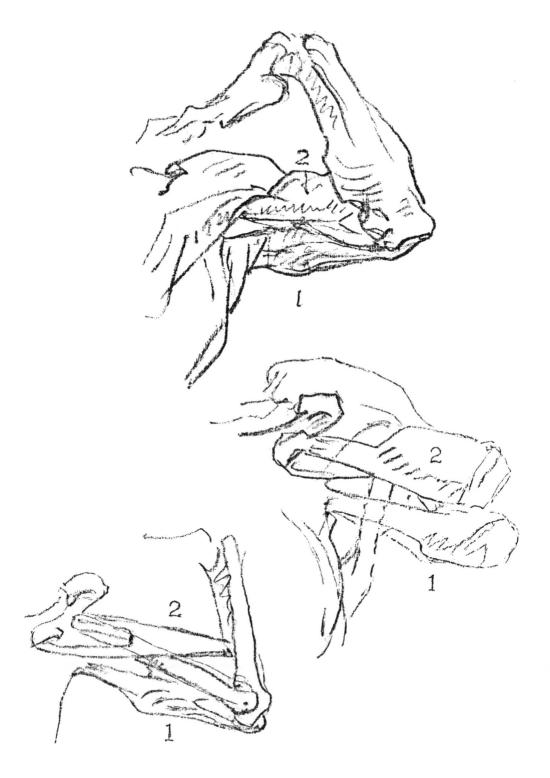

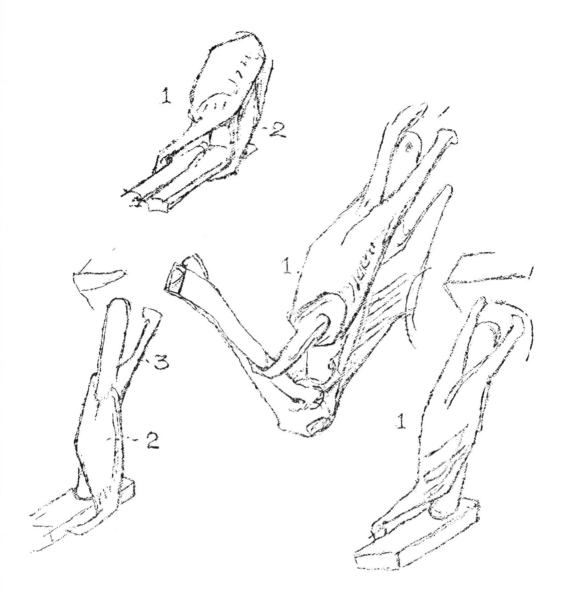

MECHANISM OF THE ARM

Engines of the human body not only bend the body levers by muscular force, but serve as well as brakes, that allow a slow reaction. This is a gentle relaxation of the opposing muscles. For instance, the biceps and the brachialis anticus muscles are placed in front of the upper arm and by their contraction, they bend the elbow. If power ceased altogether, it would let the forearm drop down. The same mechanism of slow motion pertains in all the limbs and in every movement of the body.

1. Biceps. 2. Brachialis anticus. 3. Coraco brachialis.

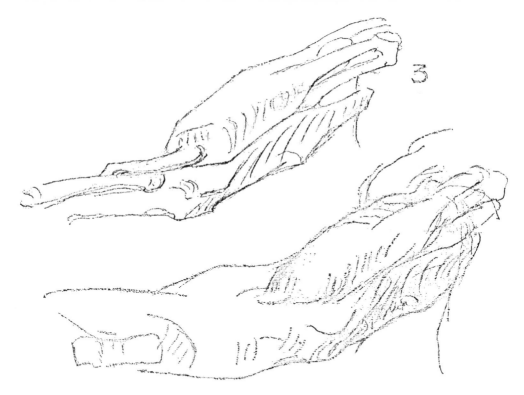

ARM ... INNER VIEW

The biceps and the brachialis anticus muscles covers the whole front of the upper arm. The bone beneath is named the humerus, it is pivoted or jointed at the elbow to the forearm. The elbow is its fulcrum. The power that draws these two portions of the arm toward each other is the brachialis and the biceps. The brachialis is a broad muscle lying under the biceps. It arises from the lower half of the humerus near the insertion of the deltoid. Its fibres terminate on a thick tendon and is inserted into the coranoid process of the ulna. Covering the brachialis in front, is the two-headed biceps. Its two upper attachments on the shoulder blade are called the long and short heads. The short head is attached to the coracoid process. The long head is attached by a tendon from the upper margin of the glenoid cavity. Both heads unite about half way down the arm and terminate above the elbow as a flattened tendon. Both the biceps and brachialis anticus bend the elbow and flex the forearm on the arm.

In the upper arm it is easily seen that there is an exact relation between the elbow joint and the muscles which move it. The muscular tendons are placed in such a direction, that by their contraction or relaxation, they raise the forearm as well as help in its rotary motion.

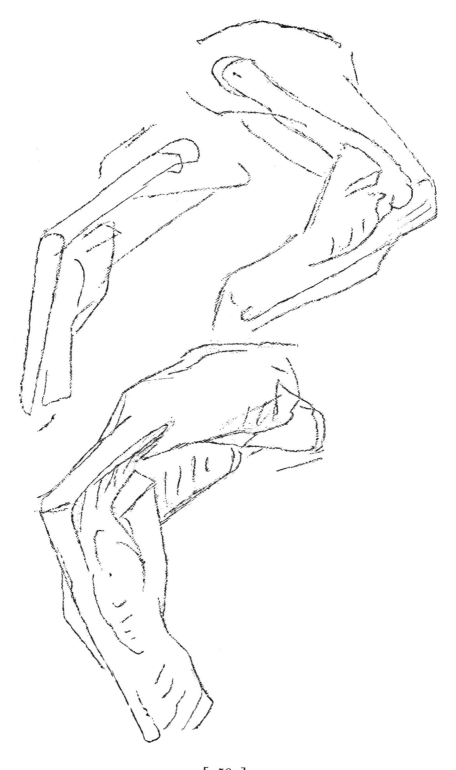

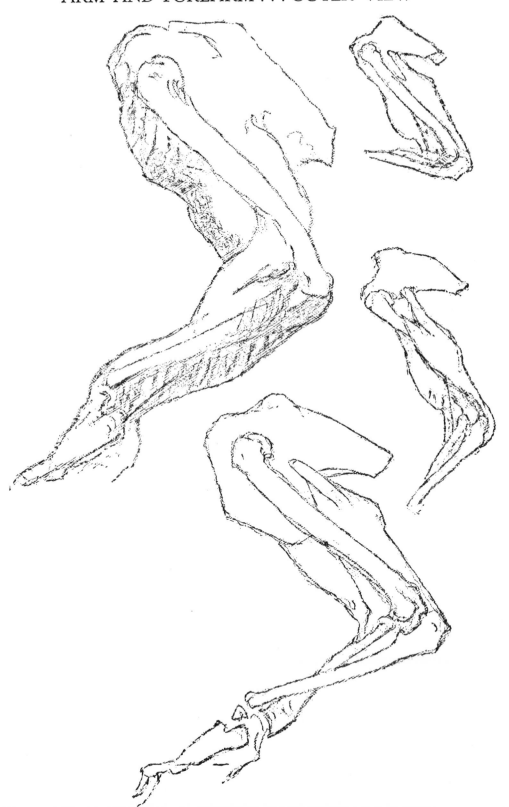

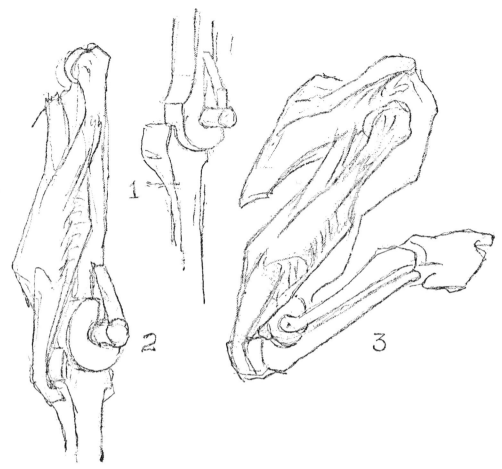

SIDE VIEW
THE MECHANISM OF THE ELBOW

1. The ulna swings on the pulley of the humerus. The articu-lation is known as a hinge joint.

2. Shows the mechanical device used in straightening the fore-arm, on the arm, at the elbow. The common tendon of the triceps grasps the olecranon of the ulna, which in turn clasps round the spool-like trochlea of the humerus.

3. When the forearm is flexed on the arm, the ulna hooks round the pulley-like device of the humerus. The triceps on this position is opposed by the biceps and brachialis anticus in front, which becomes the power that raises the forearm upward. The tri-ceps in reverse is inert and somewhat flattened out. This machine-like contrivance resembles in many ways, a limited pully-like move-ment.

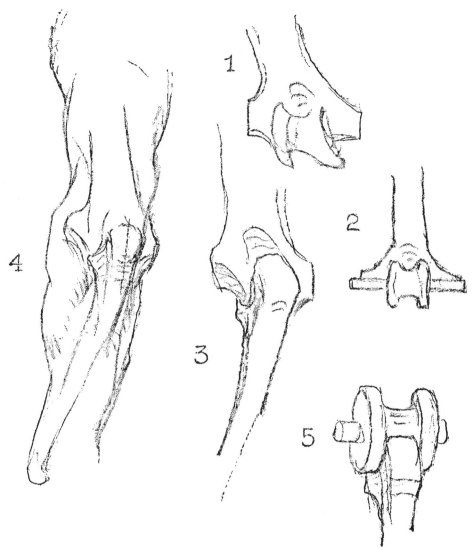

ELBOW ... BACK VIEW

1. The humerus at the elbow is flattened in front and back, terminating in two condyles. Between these is placed the trochlea, a rounded spool-like form that is clasped by the olecranon process of the ulna.

2. This is a diagram of the spool-like form of the trochlea with the embracing condyles at the sides.

3. From the back, the olecranon process of the ulna is lodged into the hollowed out portion of the back of the humerus, forming the elbow point.

4. This shows the bony structure of the hinge joint at the elbow.

5. As a mechanical device, used at the elbow, it is essentially the property of the machine age.

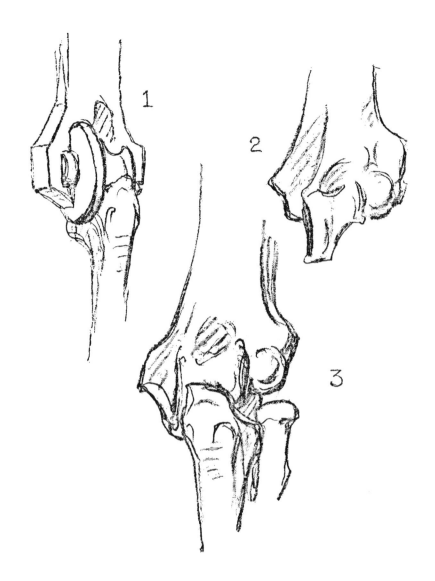

ELBOW

A pulley is one of the six mechanical powers. It is used in the construction of the hinge-like movement of the forearm.

1. The upper extremity of the elbow as seen from the front. The inner surface of the coranoid process of the ulna is curved so as to clasp the pulley-like trochlea of the humerus.

2. The lower extremity of the humerus is somewhat flat. Projecting from each side are the internal and external condyles. Between the two is the rounded groove that receives the lip of the ulna.

ELBOW ... FRONT VIEW

3. Here the bones of the arm and forearm are connected. This is a view from the front. The humerus above shows the two condyles with a notch that receives the coranoid process of the ulna, when the arm is bent. The ulna at the elbow swings hinge-like on the bone of the upper arm. It moves backward and forward in one plane only. Just below the outer condyle of the humerus is a small and rounded bursa called the radial head of the humerus. On the surface of which rolls the head of the radius.

The large bone, which carries the forearm may be swinging upon its hinge at the elbow, at the same time that the lesser bone which carries the hand may be turning round it. Both these bones of the forearm, the radius and ulna, have prominent ridges and grooves. They are directed obliquely from above, downward and inward. The radius turns round the ulna in these grooves and on the tubercles at the heads of both bones.

The lower extremity of the humerus gives a key to the movements of the elbow joint. Above, the shaft of the humerous is completely covered by the muscles of the upper arm. Below, the inner and outer condyles come to the surface near the elbow. The inner condyle is more in evidence. The outer one is hidden by muscle, when the arm is straightened out. When the arm is bent, it becomes more prominent and easier to locate.

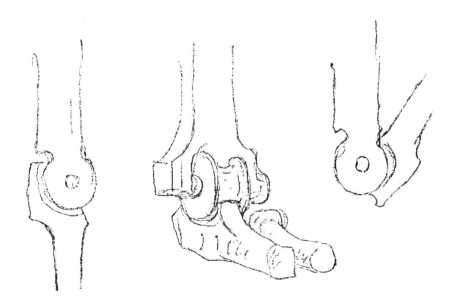

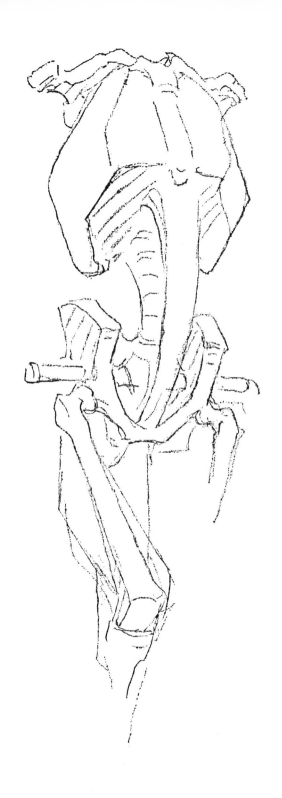

THE SKELETON

The movable articulations of the human body are named after movements that are strictly mechanical.

Machines are instruments interposed between the moving power and the resistance. In the human body it is also power and resistance, both flexible and complicated, made up of levers and joints such as, the pivot, the hinge, the ball and socket, as well as a rotating movement, which would be static but for muscular power. Thes kull, balanced as it is on the atlas, makes the skull a lever of the first order. It is balanced like a pair of scales. The spine or back bone is a chain of joints of remarkable construction, firm yet flexible.

The hinge joint moves in one plane only, forward and backward. It is not fashioned in the same way as a hinge on a door, but is held together by tendons and ligaments that hold the corresponding parts close. In the human machine, the elbow and the knee are classed as hinge joints. The security of a hinge joint depends on lateral liganments and the tendons of the muscles which pass over them.

The ball and socket joint is a machine-like structure. Nothing could be more mechanical. In the shoulder and the hip, the globular heads of bone fit into a cup-like cavity. A flexible ligament is inserted into the head of the ball, and the other end into the bottom of the cup. This keeps the two parts of the joint firmly in their place.

The lower limbs having to support the body, as well as to allow a great degree of movement, demands a more solid and a deeper articulation. The rotating movement of the forearm from the elbow to the wrist is another mechanical contrivance.

In the human or animal frame, some knowledge of the bony structure is necessary. To the study of the exact relation between the bones, their joints and the muscles which move them. Movable joints should be well understood even when no motion is intended or wanted, to carry the marks of proportion. First there is the axial skeleton consisting of the spine or back bone. The skull and bones of the face are considered part of the axial skeleton. The component parts of the spine, the thorax and the pelvis complete the bony structure.

I

1
2
3
4

II

1
2
3

III

IV

THE TRUNK ... FRONT VIEW

BONES: I

1. The sternum or breast bone, the median line of the chest.

2. The thorax or chest is the cavity that is enclosed by ribs and cartilage. The sternum is in front and the dorsal vertebræ is behind.

3. The bodies of the five lumbar vertebræe where most of the bending and turning of the trunk takes place.

4. The pelvis or pelvic basin. Consists of the two hip bones and the sacrum, united by cartilage at the pubis in front, together with the sacrum behind.

MUSCLES: II

1. Rectus abdominus muscle forms a long fleshy band on both sides of a center line of the torso. It is quite wide above at the cartilages of the fifth, sixth and seventh ribs, tapering downward to its narrowest part, where it attaches to the public symphysis of the pelvis. It is not continuous, but is crossed by transverse white lines, the leania alba. These intersections vary in number, but are usually seen as three sheathed portions.

2. Internal oblique is a fibrous sheathing that arises from the lumbar facia and the crest of ilium. It radiates forward and upward to be attached to the fascia of the three lower ribs.

3. The external oblique muscle is attached above to the lower eight ribs, below to the iliac crest of the pelvis and across by an aponeurosis to the abdomen and the rectus muscle.

III

The thorax or chest is composed of bones and cartilages so as to protect the most vital parts of the body, the heart and the lungs. The thorax protects and still permits the facility of movement and motion and allows the act of respiration. The ribs accommodate themselves to the change of form and not to the change of the bones, due to the elasticity of the cartilages. The thorax or rib cage is cone shaped with the base below and narrow above. Due to the clavicle and shoulders, the upper portion of the rib cage appears to be broadened out and the actual shape of the thorax is to a great extent, lost to view.

IV

The masses of the torse are: the chest, the abdomen and the pelvis, between them, the epigastrium. The first two are comparatively stable, and the middle one is quite movable. The rectus abdominus, the internal and external obliques all flex the thorax on the pelvis and have great influence on the surface form. The digitations of the external oblique are plainly marked at their origin, from the ribs as they intermingle with the serrations of the serratus magnus above.

THE PLANES OF THE TRUNK
FRONT VIEW

From the front, the masses of the trunk may be divided into three distinct planes. First, a line drawn from the inner third of each collar bone to the base of the breast muscles at a point to where they take an upward direction to their insertion on the upper arm, thus making a triangular form with its base on the sixth rib. Second, the epigastrium forms the upper part of the abdominal region. For our purpose, it is a flattened plane bordering the breast muscles above and the stomach below. The third plane is more rounded and is bounded at the sides by the lower ribs and pelvic bones. It is placed in the lower cavity of the trunk and is called the abdomen.

These masses of the trunk, the chest, the epigastrium and abdo-men are comparatively stable, the middle one movable. By bending the second finger, when viewed from the palmer side, these three planes give in miniature the triangular, the square and the rounded forms of the trunk.

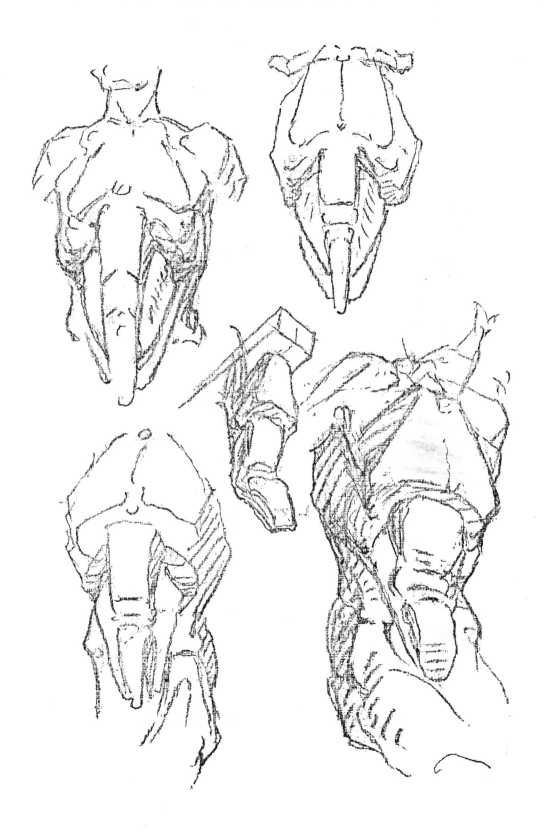

MUSCLES

1. Pectoralis: pertaining to the breast.
2. The erect and serrati: the deep muscles of the spine.
3. Muscles that pull the arm down: the pectoral; latissimus dorsi.
4. Abductors: draw the thigh toward the medium line.
5. Tendons that pass through a loop or slit: omo-hyoid; digastric.
6. Pulley: knee-cap, tendon and ligament.
7. Rectus upright: abdominal and of the femur.
8. Rhomboideus: rhomb shaped, not right angled; from the shoulder blade to the spine.
9. Deltoid: delta shaped, triangular, equilateral of the shoulder.
10. Trapezius: table shaped.
11. Oblique, slating.

MUSCLES

The motion of the human body is performed by the muscles and their tendons, they are as strictly mechanical as the wires and strings that move a mannikin in a puppet show. Muscular engines reload and discharge automatically. When compared to the engines of a motor car, the difference is that combustion takes place, not during the driving stroke, but at intervals that separate such strokes. Engines made by man exert their power by pushing, while the human engines move by pulling. Mechanical force is rigid while muscular force changes shape with every movement of the body. Muscles are the fleshy part of the body which surrounds the bones. These muscles are of fibrous texture and with their tendons motion is performed. Each muscle has its purpose, it draws or pulls the part to which it is attached.

There is an exact relation between the joints and the muscles which move the joints. Whatever the joint is capable of performing, the muscle is capable of moving. All muscles of the body are set in opposing pairs and in movement they are balanced to each other. When a muscle is contracting hard, its opponent yields, yet offers enough resistance to steady the part being moved.

Muscles are formed by bundles of fibres which have the power of changing their form by contraction, and present a very different shape when in a state of repose. Muscles are named in various ways, sometimes from the region they occupy or from their direction or their size or shape or as to their mechanical actions. Some of the simple movements are easily understood, such as, those that cover the cylindrical bones of the arm and thigh where the muscles parallel the bone, which by contraction give a hinge-like motion to both elbow and knee. At the shoulder and hip joints, the ball and socket allows a rotary movement of the limbs to which the different directions of the muscles correspond.

Muscles are the fleshy part of the body. They, with their tendons are the instruments, by which animal motion is performed. Besides the muscles just mentioned that move the hinged joints and those that give a rotary motion, there are the muscles that are given an oblique direction as well as those that run diagonally across a limb. These are, the sartorius and the tibialis muscles of the thigh and the leg. These different muscles act by contraction and in no other way.

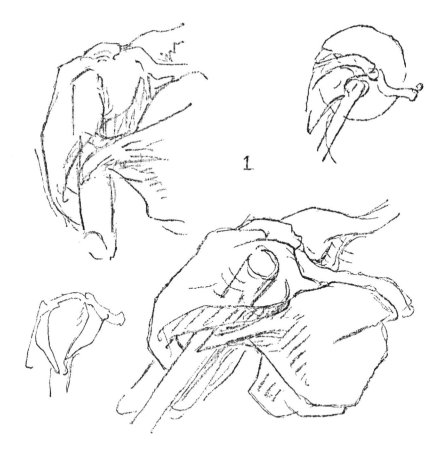

1. The deltoid muscle resembles a delta in shape. It arises from the outer third of the clavicle and the convex border of the acromion and runs the entire length of the spine of the shoulder blade. All three portions are directed downward. The middle portion is vertical and the inner and outer descend obliquely, to be inserted by a short tendon into the outer surface of the humerus. Nature allows these three portions to work in harmony. The deltoid, when all three portions are working, pull the arm up vertically. The portions that pull diagonally from the collar bone, and from the crest of the shoulder blade, carry it forwards and backwards.

2. The pectoralis major muscle twists upon itself when the arm is down. When the arm is extended or raised above the head, its fibres are parallel. When drawing a pectoral seven points should be noted: No. 1, Where the tendon leaves the arm. No. 2, Its attachment on the collar bone. No. 3, Where it meets at its step down from clavicle to sternum. No. 4, Its descent down the sternum. No. 5, Its attachment to the seventh rib. No. 6, Then across till it leaves the sixth rib. No. 7, The location of the second and third ribs that are just below the pre-sternum.

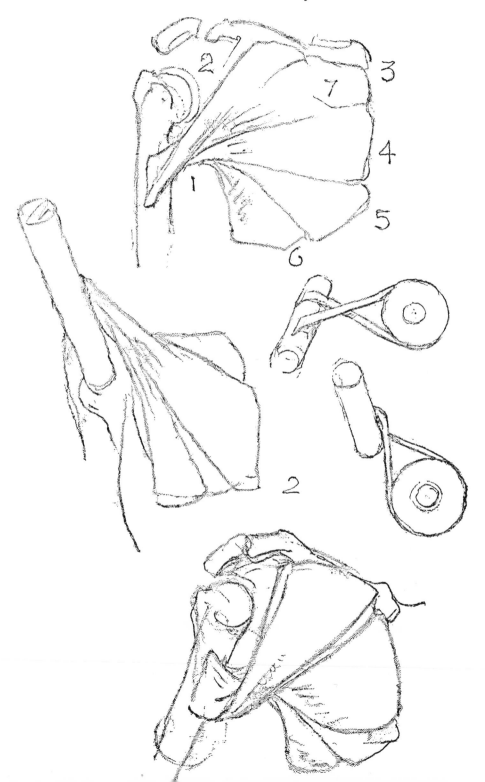

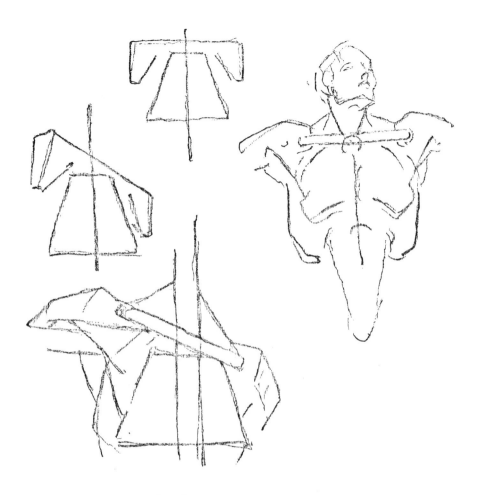

SHOULDER GIRDLE

Shoulder blades are embedded rather than attached to the back. They move from their attachment at the summit of the blade to the collar bone and are raised, lowered, or twisted by muscular force. The movements of the collar bones and the shoulder blades are free except where the collar bone joins the sternum in front. These bones curve around the cone shaped thorax, and are known as the thoratic girdle. This girdle, except at its attachment at the sternum, may be raised or lowered; thrown forward or twisted round the static rib cage without interfering in any way with the act of expiration or inspiration. There is a space between the borders of the shoulder blades at the back and in front and between the two ends of the collar bones. The muscular power that raises the shoulders away from the rib cage when set in motion, work against each other with perfect balance.

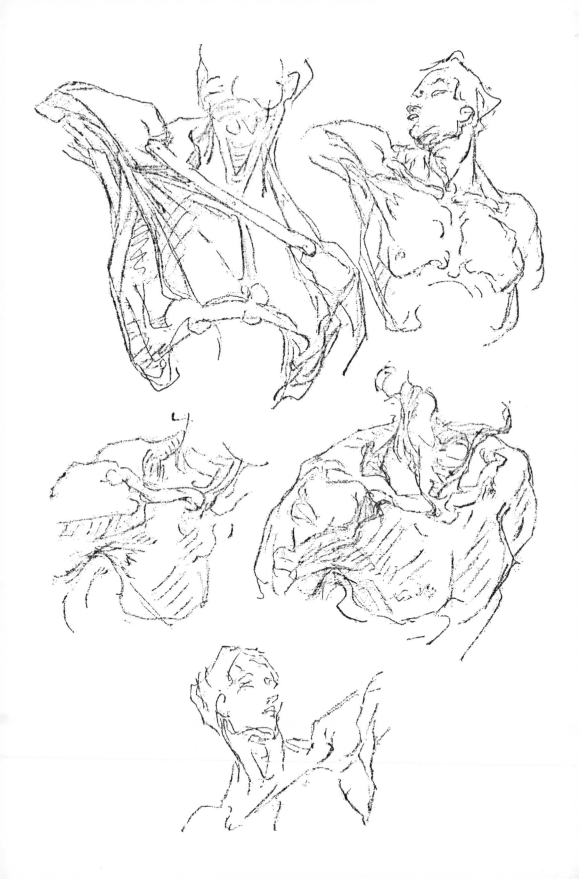

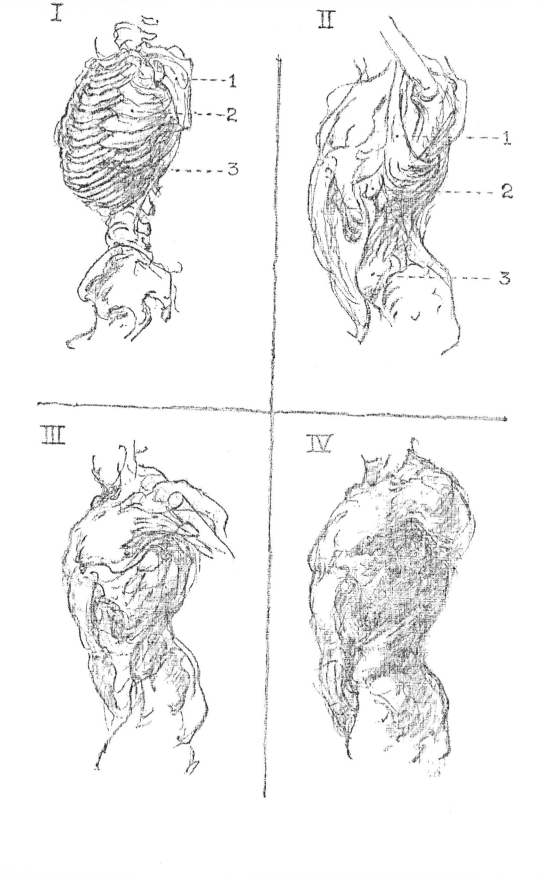

TRUNK ... SIDE VIEW

BONES: I

1. Scapula, (shoulder blade), a large flat bone triangular in shape. It articulates with the collar bone at the summit of the shoulder.

2. The serratus magnus muscles follow the ribs. See Muscles No. 2.

3. The thorax or rib cage is the cavity enclosed by the ribs, attached to the spine behind and to the sternum in front. The upper ribs are quite short and grow longer till they reach the seventh rib, which is the longest and the last to fasten to the breast bone. The upper seven ribs are named the true ribs.

MUSCLES: II

1. The latissimus dorsi muscle covers the region of the loins to be inserted into the upper part of the arm at the lower border of the bicipital groove. It is a superficial muscle, a thin sheathing that find attachments at the small of the back and at the crest of the ilium near the lumbar and last dorsal vertebræ.

2. The serratus magnus muscle is seen only at its lower parts as prominent digitations that show on the side of the thorax or rib cage below the arm pit. A large portion of this muscle is covered by the pectoralis major and the latissimus dorsi muscles.

3. The external oblique is attached above to the lower eight ribs, where they interlock with the serratus magnus. From here they are carried downward to be attached to the iliac crest.

III

The serratus magnus draws the shoulder blade forward and raises the ribs. The latissimus dorsi draws the arm backward and inward. Its upper border curves backward at the level with the sixth or seventh dorsal vertebræ, as it passes over the lower angle of the shoulder blade.

IV

In profile, the torse in front is marked by the ridge of the costal cartilage that forms its border. Sloping up and forward, and by the ribs themselves sloping down and forward, the digitations of the serratus magnus meet the external oblique.

In its attachment to the crest of the ilium, the external oblique forms a thick oblique roll, its base marking the iliac furrow. When one side of this muscle contracts, it gives the trunk a movement of rotation to the right or left side. When both sides pull, the oblique muscles draw the ribs downward, thus bending the body forward.

The serratus magnus muscle forms the inner wall of the arm pit. Its insertion to the ribs above are not seen, while those below, three or four in number are plainly visible in the region between the great pectoral and the latissimus dorsi.

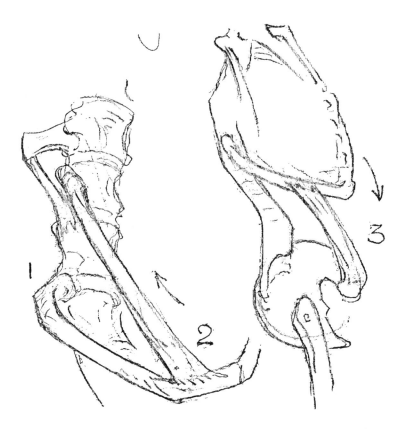

RIB CAGE

1. The fulcrum or hinge on which the lever works.

2. The ribs have to be lifted by muscular force.

3. The front end of the rib is lowered and raised by muscular force. Whether ascending or descending, the muscles hold or balance the axis on which the ribs turn. They are worked by two muscular engines, one that raises and expands the chest and the one that pulls the cage down. These opposing muscles are known as elevators and depressors.

The enlargement and contraction of the chest depends on the the mechanical contrivance of the bones which enclose it. The ribs articulate to the sides of the backbone from where they project obliquely downward. When they are pulled upward, they are at the same time being pulled outward, which brings them more to a right angle to the spine, causing the sternum or breast bone to which they are attached at the front, to be thrust forward. The muscular bands that enlarge and contract the chest pass upward obliquely from pelvis to the front and sides of the rib cage.

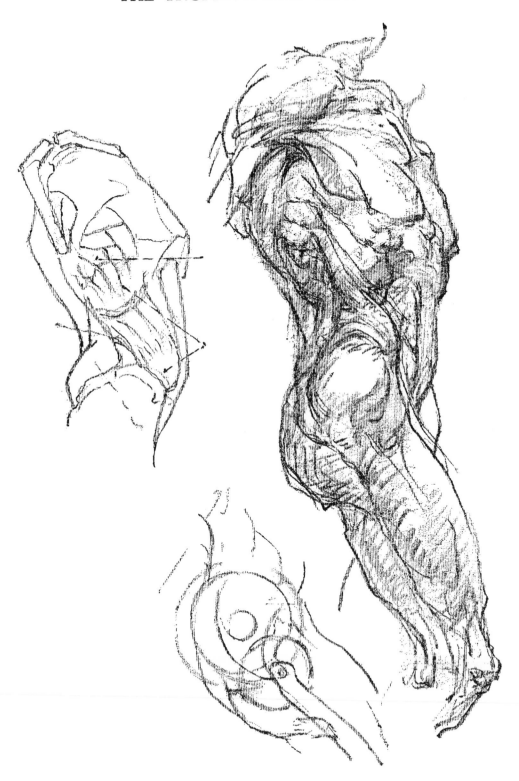

I

1

2

3

4

II

1

2

III

1

2

IV

1

2

BONES: I

1. Ribs are long, circular bones. Seen from the back these bands of bone are not horizontal but oblique from above downward. On each side of the median line the ~~transverse~~ processes and the angles of the ribs are sometimes seen. The most conspicuous of these is the projection known as the seventh cervical, the last vertebræ of the neck.

2. In shape, the thorax back or front is a truncated cone with its base below, its apex above.

3. The lumbar vertebrae, five in number, are the largest segments of the spine.

4. The sacrum is a large triangular bone to which two iliac blades of bone are united.

MUSCLES: II

1. There are long strips of muscle that fill up the grooves on each side of the spine. They pass from the lumbar to the dorsal region of the back and diminish in size as they ascend.

2. At the lumbar region of the spine the erector muscles are seen, as a large fleshy mass just above its attachment to the spines of the sacrum and the latter portions of the ilium sacro lumbalis.

III

1. Muscular bands of the sacral and lumbar regions.

2. The fan shaped serratus are inserted into the upper borders of the ninth to the twelfth ribs and are the deep seated muscles of the back.

The rib cage and the pelvic region are pivoted or jointed at the portion of the back known as the lumbar region. The power that moves these masses are muscles that extend from the pelvis to the upper-most dorsal vertebræ and the ribs at the back. There are but two comprehensible forms that tilt and twist on one another. They are the oval of the ribs and the squareness of the pelvic region. In the moving of these masses the muscles expand, shorten and bulge. These bundles of muscles and fibre that sustain the back are covered above and below by an aponeurotic sheathing that covers the small of the back at the loins. These two large masses must convey to the mind an impression of volume and solidity. The manifold smaller forms, which show on the surface, become secondary.

IV

1. The trapezius muscle arises from the median line of the back from the occipital bone and spinus ligament to be inserted into the spine of the shoulder blade and the outer third of the clavicle.

2. The latissimus dorsi muscle from the spines of dorsal lumbar (and sacral-vertebræe). The pelvis and the iliac crest to be inserted into the humerus at the bottom of the bicipital groove.

MECHANISM OF THE TRUNK AND HIPS

The cage and the pelvic bones are connected by a portion of the spine called the lumbar region. Muscular power act on these masses as levers and allow the body to move forwards and backwards or turn. The pelvis can be compared to a wheel with only two spokes, the hub is the hip joint and the spokes are the legs which swing back and forth as in walking or running. When force is applied to the long end of a lever, the power is increased. When speed is desired, the lever is shortened.

The muscular power of the human body can only pull upon and bend the levers at the joints, when the masses of the back and pelvis are bent backward or forward, or to the side. The movement of the back is limited to the extent that the bony structure of the spine allows. Each segment of the spine is a lever, upon which the masses of the rib cage and the pelvis bend or turn. From the rear, the torse presents a great wedge with its apex directed downward. The base of the wedge is at the shoulders. This wedge is driven in between the two buttresses of the hips. In movement these two masses turn or bend.

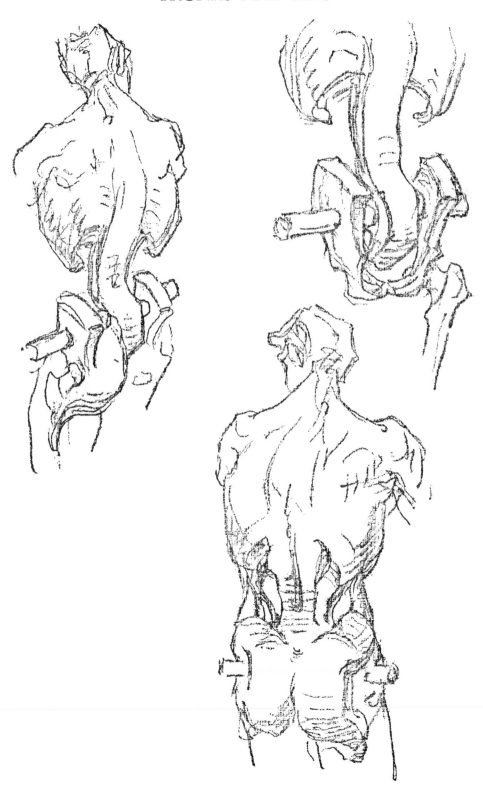

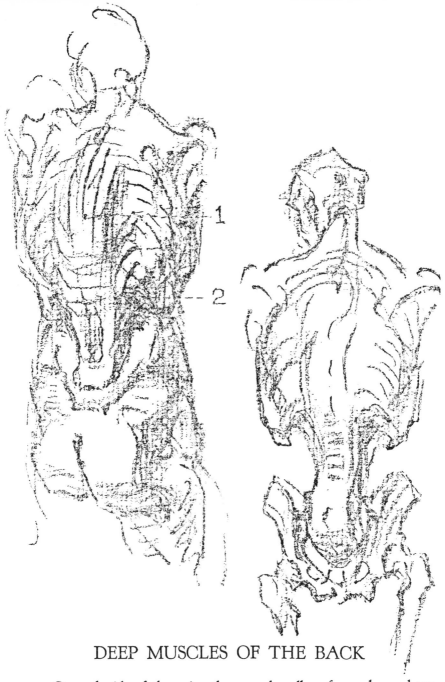

DEEP MUSCLES OF THE BACK

On each side of the spine there are bundles of muscles and tendons that arise from the latter portion of the iliac bones and the sacrum. They pass upwards by slips and fibres to the ribs and cervical vertebrae. Muscular fibres fan outward and upward to some of the lower ribs. They come from the last dorsal and lumbar vertebræ.

1. The deep muscular layers of the back are the erectors of the spine.
2. The posterior muscles fan outward toward the sides of the ribs.

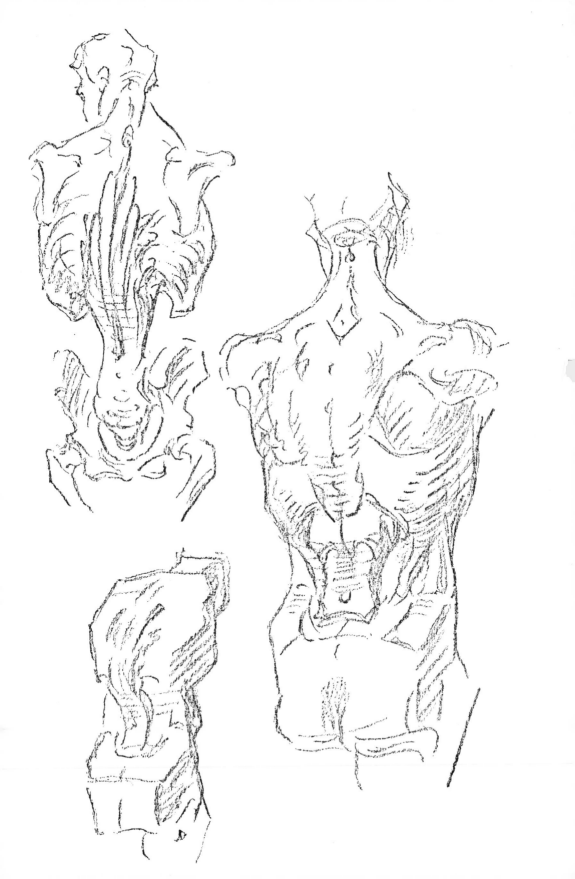

1. The trapexius and the latissimus dorsi muscles form by themselves the superficial layer of the back. A trapezium is a geometrical figure having four sides. In shape it resembles an elongated diamond. Four points mark the extreme borders. Above it is inserted into the inner third of the curved line of the occipital bone at the back of the skull, and to the spinous process of the seventh cervical vertebrae. The next point of the diamond is the spinous process of the twelfth dorsal vertebrae which marks its base. All these insertions correspond to the middle line of the back. Above and at the base of the skull the trapezius is carried outward and obliquely downward toward the shoulders to be attached to the spine of the shoulder blade at the back and to the outer third of the collar bone in front. The points of the elongated diamond shaped trapezius is now complete.

2. The latissimus muscle extends from the region of the loins to the upper part of the arm. It arises from a broad triangular aponeurosis. An aponeurosis is a fibrous expansion of the tendon giving attachment to muscular fibres. This lamina of the latissimus dorsi arises from the fifth or sixth dorsal. To all the spines of the lumbar and upper portion of the sacral to the iliac crest as well as the third or fourth ribs, to be inserted into the humerus at the bottom of the bicipital groove. (The trapezius and the latissimus dorsi form in themselves, the superficial layer of the back). The trapezius draws the head backwards. The latissimus draws the arm backwards and rotates it inwards as well as help draw the arm down.

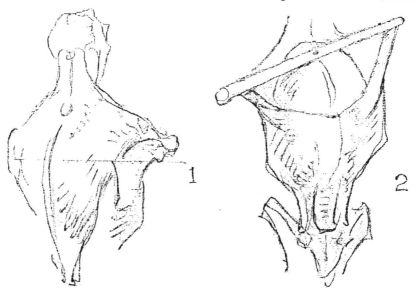

1. Trapezius muscle. 2. Latissimus dorsi muscle.

SUPERFICIAL MUSCLES OF THE TRUNK
BACK VIEW

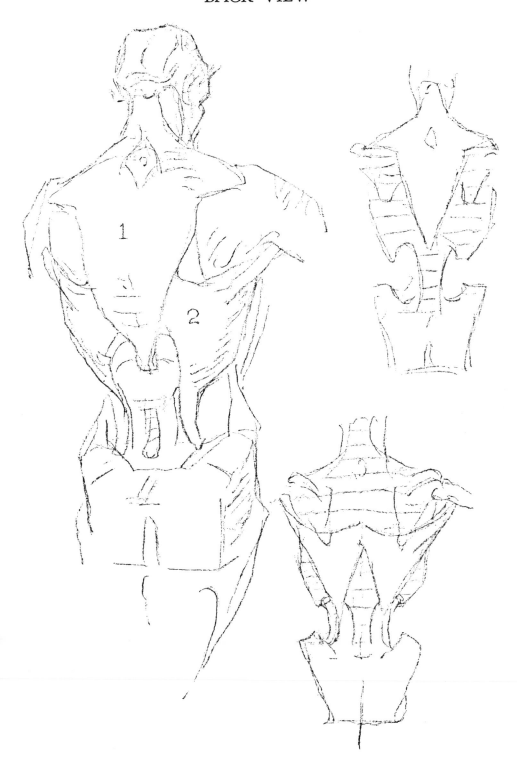

BACK...SURFACE FORM

The mass of the torso from the rear, presents a great wedge, (its apex downward). It shows many depressions and prominences. this is due to the bony structure and to the layers of muscle that cross and recross the back. From the shoulder blade above, both ridge and blade are seen as grooves or ridges under the skin. These are looked upon as landmarks and must be recognized as such. These serrations and grooves must be traced and catalogued. The deltoid can be traced below and outside the crest of the shoulder blade; the trapezius above the crest and inside toward the seventh cervicle. This muscle also spreads from the inner end of the ridge to well down the spine. Lower down, the latissimus dorsi covers the back. Lying under these two sheets of superficial muscle are the muscles that control the movements of the shoulder blades. There is first, the levator angula scapulae. This muscle is inserted into the upper border of the should-er blade. It draws the blade upward in an almost vertical direction toward the upper vertebrae of the neck. The rhomboides muscle is inserted into the base of the scapulae, it takes a diagonal direction upward to the five upper dorsal and the seventh cervicle. The ser-ratus magnus muscle lies between the shoulder blade and the ribs. It draws the inferior angle of the blade downward and forward.

The muscles that move the shoulder blade:

1. Levator anguli scapulae, raises the angle of the shoulder blade.
2. Rhomboideus major and minor, elevates and retracts the shoulder blade.
3. Serratus magnus, draws the shoulder blade forward.

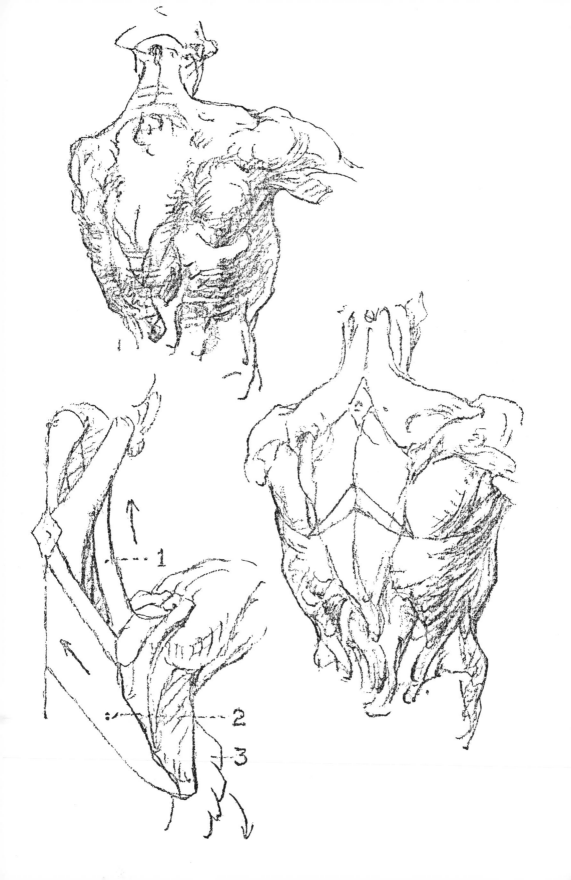

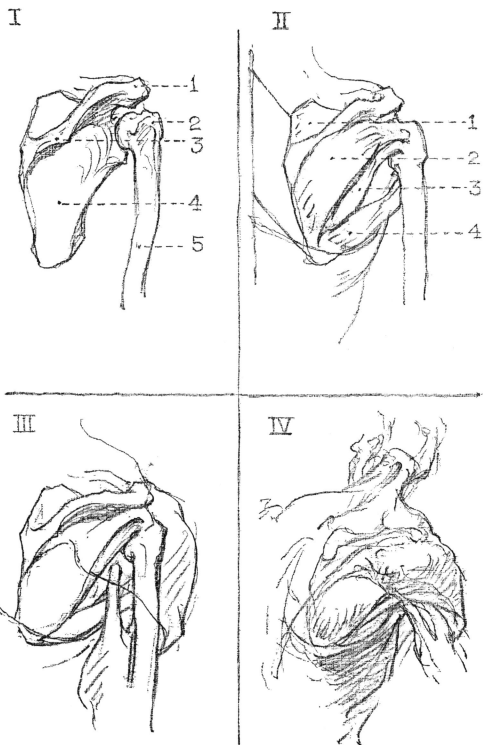

I

1
2
3
4
5

II

1
2
3
4

III

IV

SCAPULAR REGION

BONES: I

1. The acromion process is the outer end of the spine of the shoulder blade. It articulates with the clavicle.

2. The great tuberosity of the humerus.

3. The spine is a ridge running obliquely upward and outward across the shoulder blade.

4. The greater part of the infra spinous fossa of the shoulder blade is covered by the infra-spinatus muscle.

5. The humerus.

MUSCLES: II

1. The supra-spinatus muscle: occupies the upper fossa of the shoulder blade to be inserted into the upper part of the great tuberosity of the humerus.

2. The infra-spinatus: this muscle occupies the greater part of the fossa that lies below the spine of the scapula. It arises from the back of the shoulder blade to be inserted into the large tuberosity of the humerus.

3. Teres minor muscle: arises from the auxiliary border of the shoulder blade to be inserted into the humerus just below the insertion of the infra-spinatus.

4. Teres major muscle: has its origin at the lower angle of the shoulder blade. It is a round, thick muscle that ascends upward and outward to be inserted into the humerus at its inner surface near the bicipital groove.

III

The three muscles, the infra-spinatus, teres minor and teres major, are seen superficially in a triangular space that is bounded by the trapezius, deltoid and latissimus dorsi. If the arm is raised, the triangle becomes lengthened. If drawn back toward the spine, the triangle becomes shorter as it closes up.

When the arm is hanging beside the trunk, this triangular shape becomes more visible. The only articulation the shoulder blades have with the cage is through the collar bones, as this bony girdle moves, the shoulder moves.

IV

The inner or vertical borders of the shoulder blades move forward or backward, due to the raising or lowering of the arms; the rhomboid muscles swell out as they approach the spinal column, or show as shallow depressions when in reverse. The shoulder blade slides against the surface of the cage in any direction, and may be lifted from it, so that, its lower angle or its spinal edge becomes prominent under the skin.

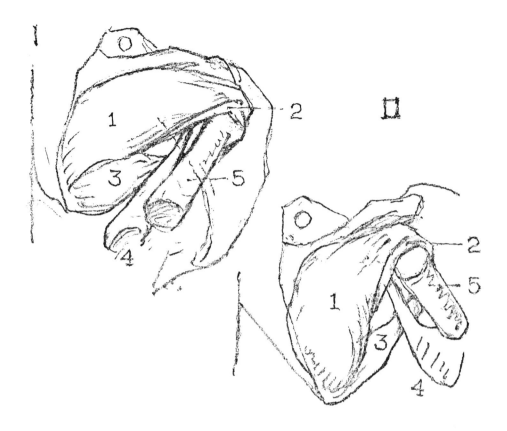

THE SCAPULA

In treating the shoulder as a mechanical device, one tries to discover its functions, its leverage and its power. The shoulder must be looked upon as the foundation of the arm.

The large diagram on the opposite page shows the muscular arrangement of the shoulder blade. The arm is separated at a distance from the shoulder, showing the devices which nature has contrived in order that the arm may be pulled forward, inward or back. The origin of all the muscles shown are on the shoulder blade, while the insertions on the arm are on both the top, front and back of the humerus. They are so placed, that when pulling against one another, their contracting fibres cause a rotary movement of the arm. These muscles entirely or in part are seen only in the triangular space bound by the trapezius latissimus dorsi and the deltoid.

0. Supra-spinatus muscle.
1. Infra-spinatus muscle.
2. Teres minor muscle.

3. Teres major muscle.
4. Triceps muscle.
5. Humerus bone.
6. Latissimus dorsi muscle.

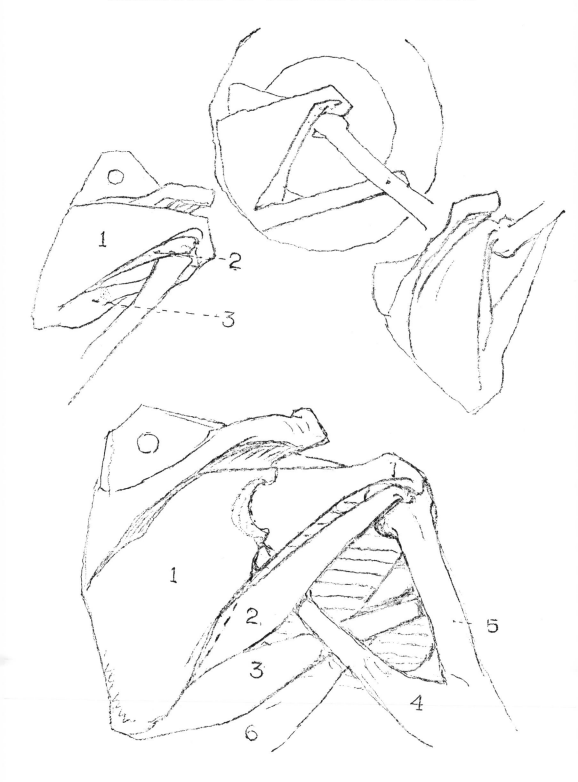

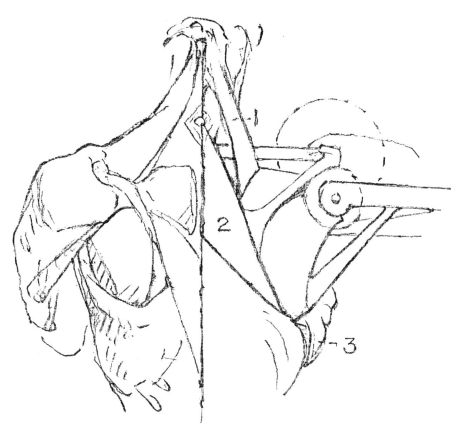

1. Levator anguli scapulae: the elevator of the scapula, raises the angle of the shoulder blade.
2. Rhombordius: arises from the seventh cervicle to the fourth and fifth dorsal. It elevates and retracts the shoulder blade.
3. Serratus magnus: from the vertebral border of the shoulder blade; draws the shoulder blade forward.

MECHANISM

1. The inner border of the shoulder blade parallels the spine when the arm is down.
2. When the arm is raised above, at right angle to the body, the greater tuberosity of the humerus presses the upper rim of the glenoid cavity. The shoulder blade then starts to revolve.
3. The horizontal bar represents the collar bone as it articulates with the sternum at the front, and with the acromion process of the shoulder blade at the summit of the shoulder.
4. The axis on which the shoulder blade turns, (seen from the back) is where the collar bone and the crest of the shoulder blade meet.
5. The shoulder blade or scapula.
6. The humerus: arm bone.

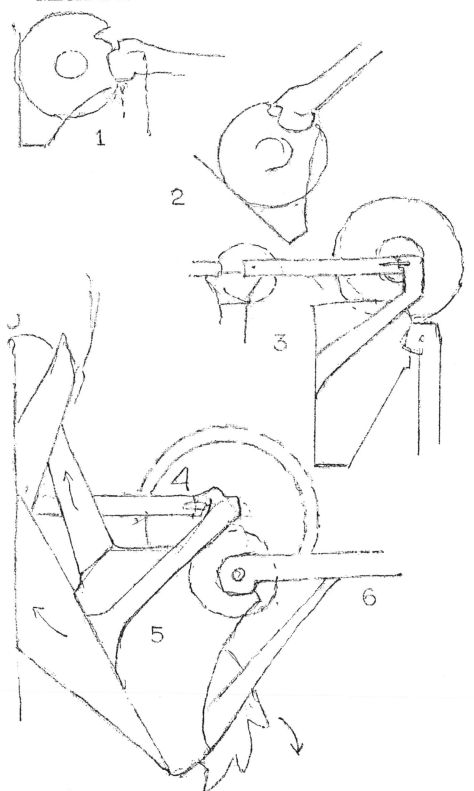

DETAIL . . . PELVIS BONE

1 - GREAT
TROCHANTER
OF THE FEMUR

2 - NECK
3 - HEAD OF
FEMUR[1]

PELVIS

EXTERNAL
VIEW

SACRUM

BACK VIEW

SACRUM

FRONT VIEW

A SECTION

AND AXIS OF
THE PELVIS

PELVIS BONE

OS INNOMINATUM
THE BONE WITHOUT A NAME

FRONT

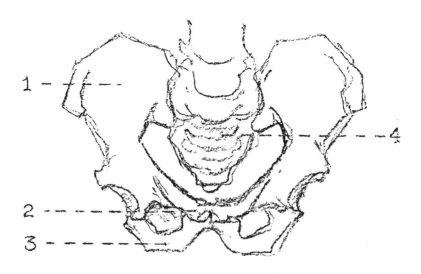

BACK VIEW

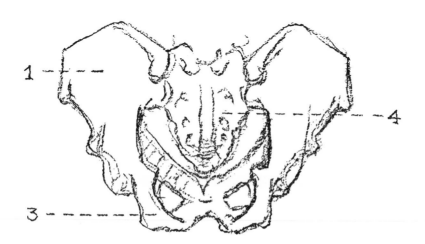

1- ILIUM 3- ISHIUM
2- PUBIS 4- SACRUM

I

1
2
3
4
5

II

1
2
3
4
5

III

IV

BONES: I

The pelvis consist of two hip bones and a sacrum.

1. The ilium or hip bone consists of two upper blades; the superficial parts are the crests, (the iliac crests).

2. The sacrum is the keystone of the pelvis. This is a wedge shaped bone that forms the central piece at the back, the last portion of which is called the coccyx.

3. The acetabulum is the socket of the hip joint; it forms the central point of the shaft of the femur.

4. Great trochanter.

5. Pubis.

MUSCLES: II

1. The external oblique muscle: from the lower eight ribs and attached to the iliac crest.

2. The gluteus medius: arises from the iliac crest and part of the outer surface of the ilium. Its descending fibres converge toward the great trochanter of the femur into which they are inserted by heavy tendons.

3. The gluteus maximus: the largest and thickest muscle of the body is directed obliquely from the sacrum and the iliac region toward the upper part of the femur to which it is attached by broad fleshy fibres.

4. The tensor femoris muscle, lies next the gluteus medius. It arises from the crest of the ilium. It is directed downward and backward on the external surface of the thigh to be inserted into the aponeurosis of the facia lata. The fibres of the tensor femoris descend on the external surface of the thigh to the knee.

5. The aponeurosis of the facia lata.

III

The weight of the body is supported on the ball shaped head of the femur which is fitted into the socket of the hip bone or pelvis. The body is poised on the head of this thigh bone. The shaft serves as a crank on which the muscles round the pelvis act. First the gluterus medius abducts and rotates and turns out the thigh. The tensor femoris tenses the facia and rotates the thigh inward.

IV

From the iliac crest, the gluteus medius forms a descending wedge; its front portion over laid by the tensor. The whole of the gluteus maximus muscle passes down and forward to below the great trochanter of the thigh bone completing the mass of the buttocks and hips.

The iliac crest is the fulcrum for the lateral muscles, it flares out widely for that purpose, the ilio-tibial band guards the outside of the thigh becoming more narrow and cord like as it approaches the outer side of the knee.

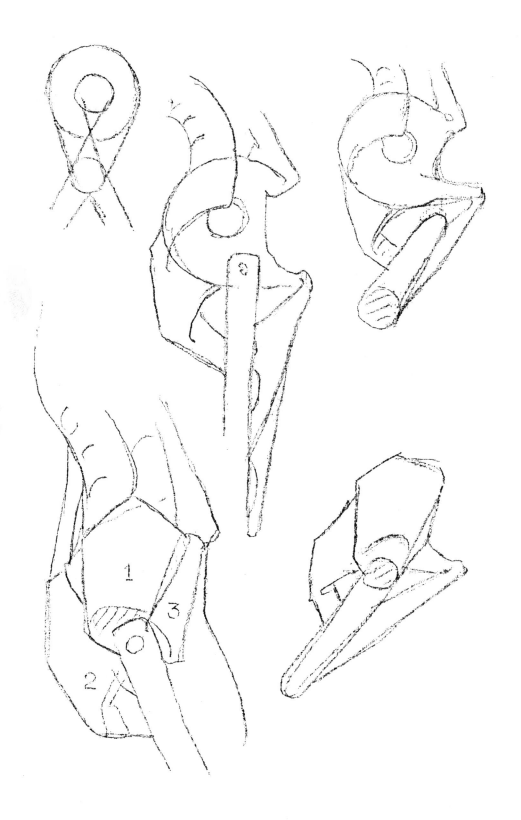

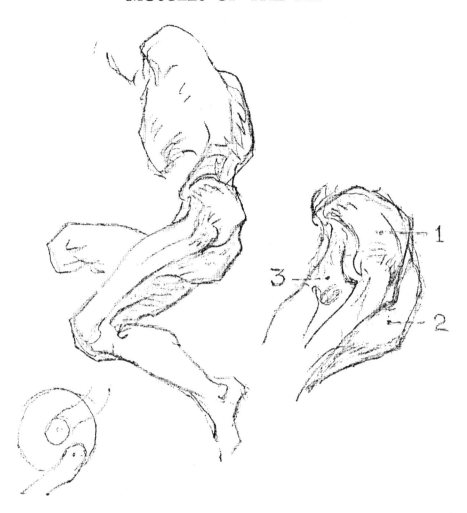

1. Gluteus Medius. 2. Gluteus Maximus.

3. Tenso viginae femorus.

Nature has provided a perfect system of columns, levers and pullies to which cords and muscles are attached. When contraction takes place, these muscles and their tendons pull, twist or turn, the movable bones. The hip joint is a strictly machine-like contrivance. It has at its connection with the hip, a ball and socket joint and a hinge joint at the knee. The muscles at the hip give a wheel-like movement. Those muscles that pass to the knee parallel the thigh bones to bend the knee.

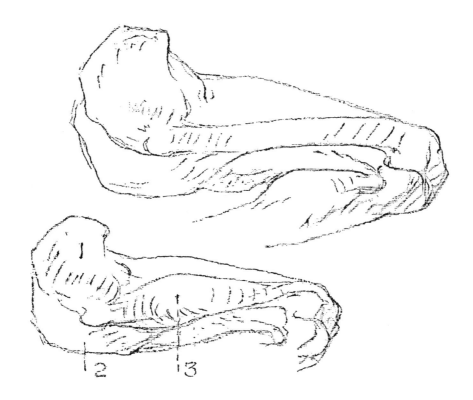

1. Glutus Medius. 2. Gluteus Maximus.

3. Vastus externus.

In the human body there is a framework of bone. This framework is called the skeleton. Muscles move this skeleton.

Bones are classified as long, short and irregular. Muscles are also classified as to length, size, shape, etc. Muscles are placed over this framework, to work its various levers, cranks and hinge-like movements. They control the movements of the trunk as well as the limbs, to swing the lower limbs as in taking a step forward. The muscular engines of the buttocks act upon the hip joint and the thigh. The extensors in front extend the leg. The hamstrings at the back to move the leg at the knee. Those at the calf raise the heel and thrust the foot forward.

To keep the body erect, the center of gravity must be continually shifting. It is an adjustment of weight, pressure and quick balancing.

HIP AND THIGH

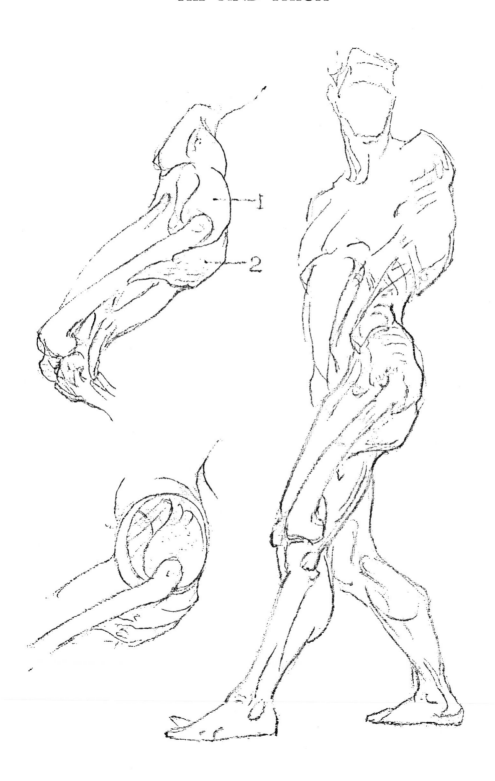

I

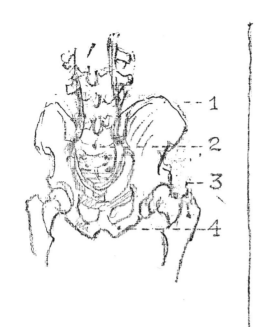

- - - 1
- - - 2
- - - 3
- - - 4

II

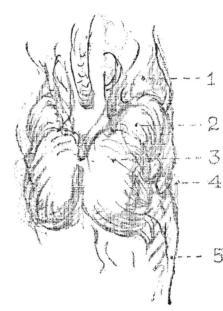

- - - 1
- - - 2
- - - 3
- - - 4

- - - 5

III

IV

BONES: I

1. Iliac crest.
2. Sacrum.
3. Great trochanter.
4. Tuberosity of the ischium.

MUSCLES: II

1. The external oblique attaches above to the eight lower ribs below to the iliac crest.

2. Gluteus medius: is from the iliac crest and the outer surface of the ilium to be inserted into the great trochanter of the femur. It may be seen lying between the gluteus maximus and the tensor faciae femorus.

3. Gluteus maximus muscle arises from the latter portion of the iliac crest, (the sacrum and coccyx). The lower half of this muscle is inserted into the back of the femur.

4. The tensor femorus muscle lies next to the gluteus medius. Its fleshy body is directed downwards to be inserted into the facia lata. The facia lata descends vertically as a band to the outer side of the knee.

5. The iliotibial band of the facia lata.

III

The gluteus maximus and medius muscles fill in the large space that is bordered by the crest of the ilium above, to where they join the sacrum at the back and the great trochanter of the femur at the sides. Its lower border passes over the large hamstring muscles of the thigh. In an upright position, the gluteus maximus supports the pelvis behind and keeps the trunk erect. It is also an extensor of the thigh on the pelvis. The muscular fibres of the gluteus medius descend from the ilium to converge toward the great trochanter, to which they are inserted. Some of these fibres draw the thigh outward, others cause the femur to turn on its axis from without, giving the thigh a rotary motion.

IV

The pelvis, due to its position, is the mechanical axis of the body. It is the fulcrum for the muscles of the trunk and lower limbs. The mass inclines a little forward and is somewhat square as compared to the trunk above. So great are the changes in the surface form of the muscles in different positions of the hip, that the iliac crest is the one stable landmark. The posterior curve of the iliac crest is marked by two dimples where it joins the sacrum. From here, the gluteus maximus continues down and forward to just below the head of the thigh bone. Only a part of the medius is superficial.

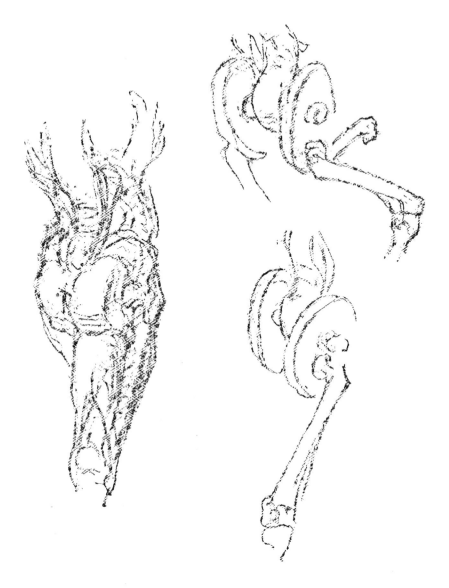

The greater part of the movement of a figure is based on the pelvis. Its bony basin in front supports the fleshy mass of the abdomen. Behind, a circle of bones forms the extreme lateral part, of which the sacrum is the keystone. The muscles that are visible are all situated at the back to form the gluteal region. Only two of these are prominent; they are, the gluteus maximus and the gluteus medius. With the pelvis as a base, these two act on the femur which acts as a crank shaft. The upper end of the femur is in the shape of a bent lever on which the whole body rests.

THE GLUTEAL REGION
BUTTOCKS AND HIP

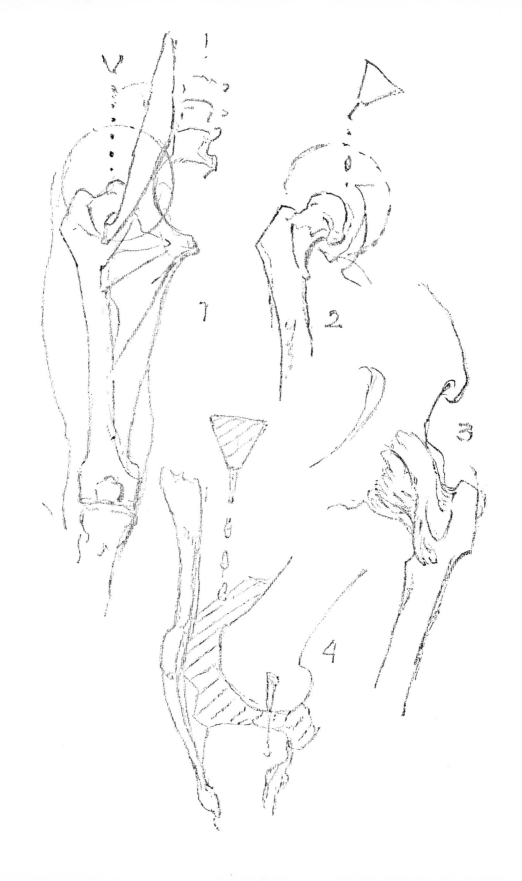

LUBRICATING SYSTEM

The human body is provided with a system of levers, pulleys and cords by which muscles pull on the movable bones.

The union of two bones that permit action is known as a joint. The ends of these bones where they come in contact with each, are tipped with cartilage. This cartilage is elastic, taking up the jar which would result if the bones came directly together in contact. The surface of the articulating cartilage is perfectly smooth. This surface resembles cellophane and is lubricated with a fluid that is attained by the actual breaking down of the cartilage itself.

It is recognized that no machine has ever been built that maintains a uniform oiling device that equals the lubricating system of the human body.

All joints are completely enclosed by a capsule which is loose enough to allow the free movement of the levers within the capsule. There are no empty spaces nor aperture for draining that will allow the lubricant to escape. A limb can swing on its hinge or in its socket many times a day for many years without losing its agility. Provision is made for preventing wear and tear. First by the polish of the cartilaginous surfaces. Second by the healing properties of the lubricating oil, and the way substance is restored and waste repaired.

1....At the hip where the ball and socket joint allows by its construction a rotary or sweeping motion, tendons and muscle pull in such directions as to produce the motion which the joint admits. Here the wires and strings, which conduct the muscular power, pull the thighs together, in both rotation and adduction.

2....The oil of the oiling system is supplied by the rubbing together the two plates of cartilage at the joint.

3....It is then capsuled and bound by strong dense ligaments which embrace the margin of the cup, (the acetabulum), above and surrounding the neck of the femur below.

4....If the joints were not lubricated, they would be stiff and creak like a hinge without oil. Membrane stretches from bone to bone confining the fluid, which is not dropped as pictured here, but actually made.

I

1
2

3
4
5

II

1
2

3
4

III

IV

BONES: I

1. Pubis; of the pelvis
2. Femur: thigh bone
3. The head of the femur
4. The neck of the femur
5. The great trochanter

MUSCLES: II

1. The rectus femoris: arises by two tendons from the pelvis to join the common tendon of the triceps femoris a short distance above the knee.

2. The adductor muscles, longus and magnus: arises from the pubic and ischium portions of the pelvis to be inserted into the whole length of the femur on its inner side.

3. Vastus externus: from the femur at the great trochanter; following a roughened line at the back of the shaft to join the common tendon a little above the knee.

4. The vastus internus: arises from the front and inner side of the femur to near the whole length of the shaft to be inserted into the side of the patella and common tendon.

III

The triceps of the thigh comprise the rectus, vastus externus and internus, adding the crureus, a deep seated muscle, which makes four in all. These four are together called the quadriceps extensor. They all meet above and around the knee to a common tendon that is inserted into the patella and continued by a ligament to the tubercle of the tibia.

The rectus is seen above as it emerges from between the tensor vaginæ femoris and the sartorius. From here it descends vertically on the surface of the thigh to join to its tendon above the knee. The rectus muscle bulges out at a much higher level than the muscles on either side. The outer muscle ends as a triangular tendon to enter the patella above the knee. The inner is placed quite low on the thigh and seen distinctly at its lower margin. It passes round the inner side of the knee to its insertion into the patella.

IV

The human body is provided with a system of levers and pulleys by which muscles pull on the movable bones. The thigh swings backward as well as forward. When in action, all the muscles that surround the hip joint are geared and set in motion. The triceps of the thigh like the triceps of the arm is composed of three muscles that act together. When they pull they extend the leg on the thigh.

The mass of the thigh is inclined inward from hip to knee and is slightly beveled as it descends as a rounded form to the flattered planes that border the knee.

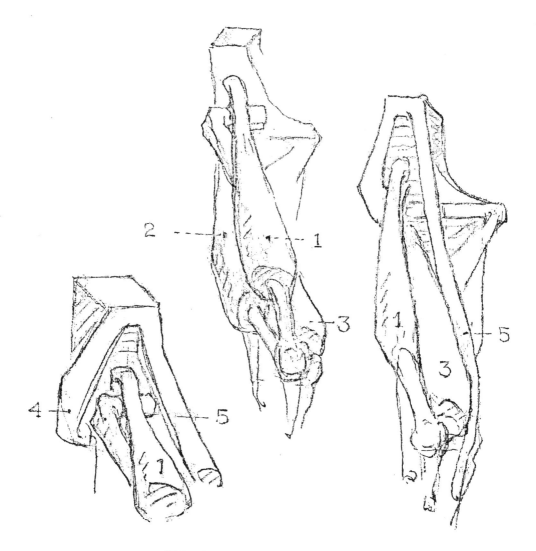

THIGH ... FRONT VIEW

MUSCLES:

1. Rectus femoris: extends the leg.
2. Vastus externus: extends the leg.
3. Vastus internus: extends the leg.
4. Tensor vaginæ femoris: the tensor of the facia lata.
5. Sartorius: flexes the leg upon the thigh; the thigh upon the pelvis and rotates the thigh outward.
6. Biceps femoris: flexes and rotates the leg outward.

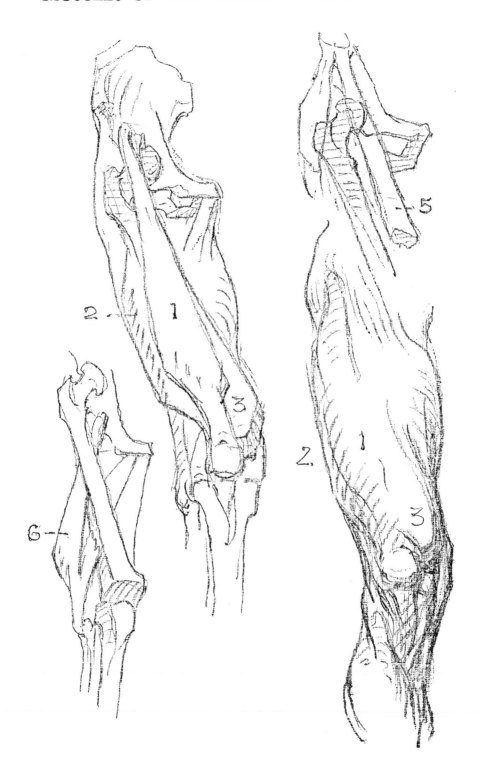

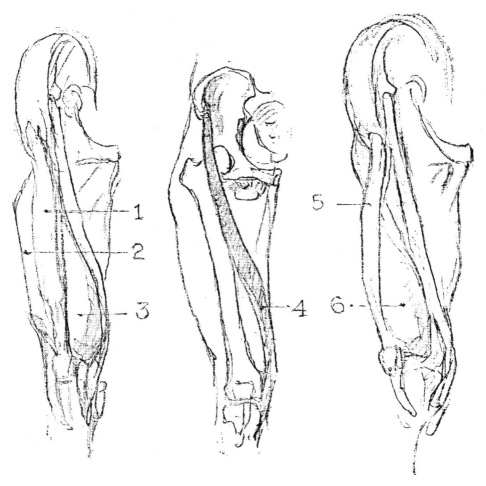

MUSCLES OF THE THIGH

1. Rectus femoris: straight muscle of the femur; extends the leg.
2. Vastus externus: great muscle outside; extends the leg.
3. Vastus internus: great muscle inside; extends the leg.
4. Sartorius: flexes the leg on the thigh, flexes the thigh upon the pelvis and rotates the thigh outward.
5. Rectus femoris muscle.
6. Vastus internus.
7. The satorius: rotates the thigh throwing one leg and the thigh over the other.
8. Tibialis anticus: from the upper part of the shaft of the tibia to the base of the metatarsal bone of the great toe. It flexes and raises the inner border of the foot.

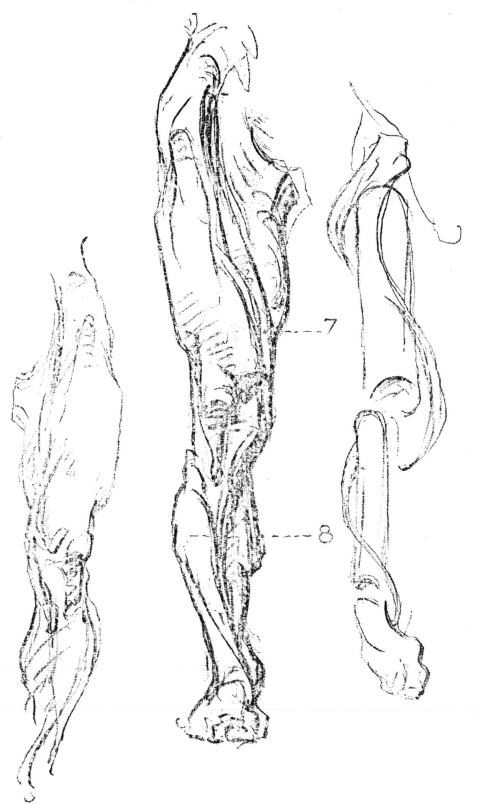

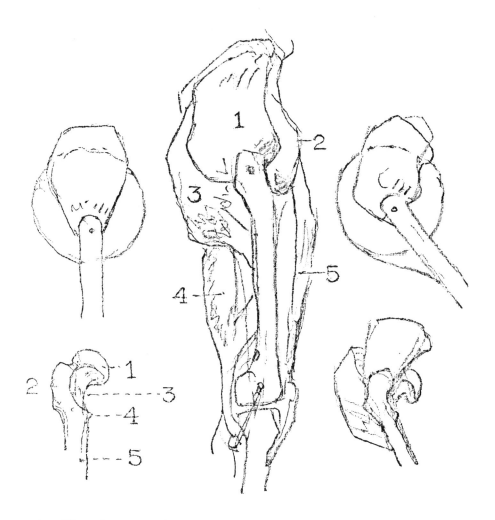

1. The gluteus medium rotates, adducts and advances the thigh.
2. The tensor vaginae femoris is the tensor of the facia lata.
3. The gluteus maximus extends, adducts and rotates the thigh outward.
4. The biceps femoris flexes and rotates thigh outward.
5. The rectus femoris extends the leg.

 1. Head of femur.
 2. Great trochanter.
 3. Neck of femur.
 4. Lesser trochanter.
 5. Shaft of femur.

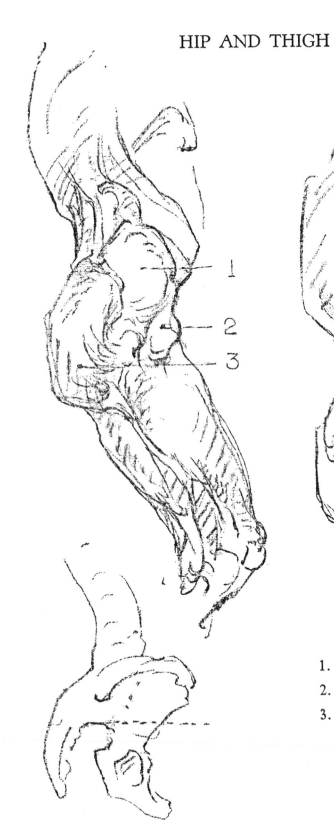

1. Gluteus medius.
2. Tensor femoris.
3. Gluteus maximus.

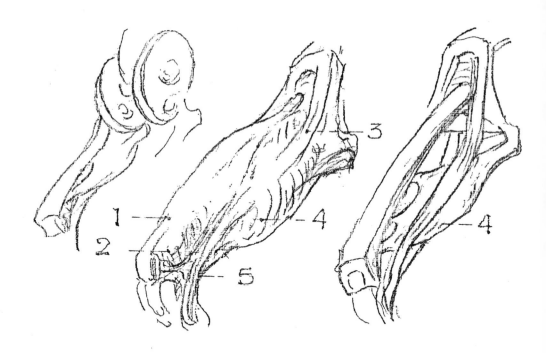

The thigh bone is the most perfect of all levers, it is balanced by the muscles that pass up from the "crank shaft", of the thigh bone to the pelvis. These muscles work against one another in turning the round slippery head of the thigh bone in the socket. The muscles parallel the shaft to control the action of the knee joint, the extensors of the leg are in front or on top when the thigh is drawn upward, while those that flex the leg on the thigh are at the back.

The sartorius arises from the crest of the ilium, it sweeps downward in a sinuous curve across the thigh, in a flattened tendon as it wraps around the inner surface of the knee to its insertion on the tibia.

INNER VIEW

1. Rectus.
2. Vastus internus.
3. Sartorius.
4. Adductor.
5. Hamstrings.

OUTER VIEW

1. Hamstrings.
2. Rectus femoris.
3. Biceps.
4. Vastus externus.

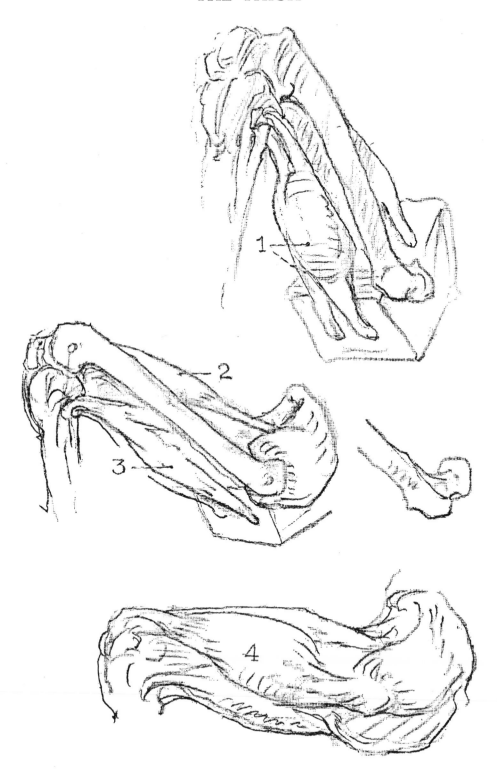

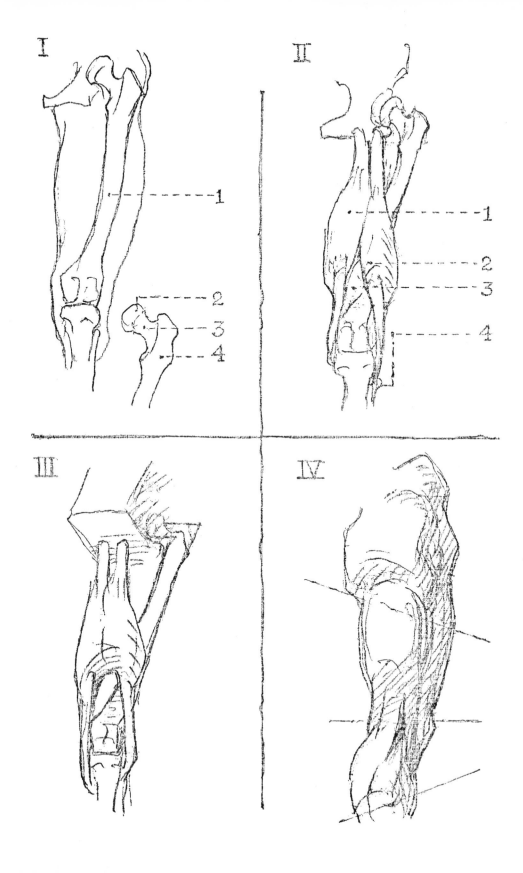

THE THIGH ... BACK VIEW

BONES: I

1. Shaft of the femur.

2. Head of the femur.

3. Neck of the femur.

4. Great trochanter of the femur.

MUSCLES: II

1. The semi - tendinosus muscle arises from the tuberosity of the ischium and is inserted into the upper part of the inner surface of the tibia. It is seen as an inner hamstring.

2. The biceps femoris is the outer hamstring and has two heads, one of which is long, and the other one short. The long head descends from the pelvis above, the short head descends from the back of the femur. A common tendon of the two portions is inserted into the head of the fibula on the outer side of the knee.

3. The semi-membranosus one of the hamstrings of the knee is located at the back of the thigh. Above, it arises at the tuberosity of the ischium. Below, it is inserted to the back of the inner tuberosity of the tibia. Above it is fibrous but becomes more muscular on its outer border just above the knee.

4. Insertion of the Biceps.

III

The muscles of the thigh from the back are three in number. They emerge from beneath the gluteus maximus and are seen as two rounded masses descending vertically. The outer mass is formed by a single muscle, the biceps. The inner mass is formed by two muscles, one on the top of the other; the semi-tendinosus on top, the semi-membranosus beneath.

The back of the knee when bent presents a hollow due to the hamstrings on either side. It is bordered above by the semi-membranosus and below by the tendons and the muscles of the calf of the leg. The diamond shaped cavity is named the popetial space. The knee and ankle are in line. The shaft of the thigh bone above is set at an angle with the leg making the inside of the knee protrude. When the thigh and leg are not bent, the joints back of the knee become more prominent and the hamstrings are less in evidence.

IV

When the thigh bone moves upward, it acts as a crank on the pelvis. The muscles swell and thicken as they pass back of the femur. These hamstring muscles have their origin on the pelvis, their tendons clasp the leg on either side just below the knee giving a hinge like motion in bending the leg on the thigh.

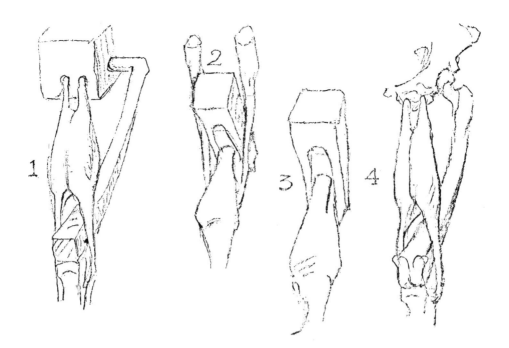

THIGH . . . BACKVIEW

1. The crank shaft of the thigh bone.
2. The hamstrings have their origin on the pelvis, and are inserted into the leg bone.
3. The back of the knee.
4. The hamstrings bend the knee and flex the leg on the thigh as well as draw the lower limb backward.
5. The semi-membranosus.
6. Gluteus medius abducts and rotates the thigh.
7. Gluteus maximus extends, rotates and turns the thigh out.
8. The hamstring muscles whose tendons are placed on either side of the knee at the back, is a dual mass of muscle dividing above the diamond shaped space at the back of the knee. The muscles with their tendons are the semi-tendinosus which flexes the knee and rotates the leg inward. The semi-membranosus flexes the knee and rotates the leg inward. The action of the biceps femoris flexes the knee and rotates the thigh outward.
9. On the back of the leg there are two muscles, the broad flat soleus, and the double bellied calf muscle, the gastrocnemius.
10. The gastrocnemius ends below in a broad tendon and joins with the soleus to form the tendo achillies. This is inserted into the oscalcis or heel bone.

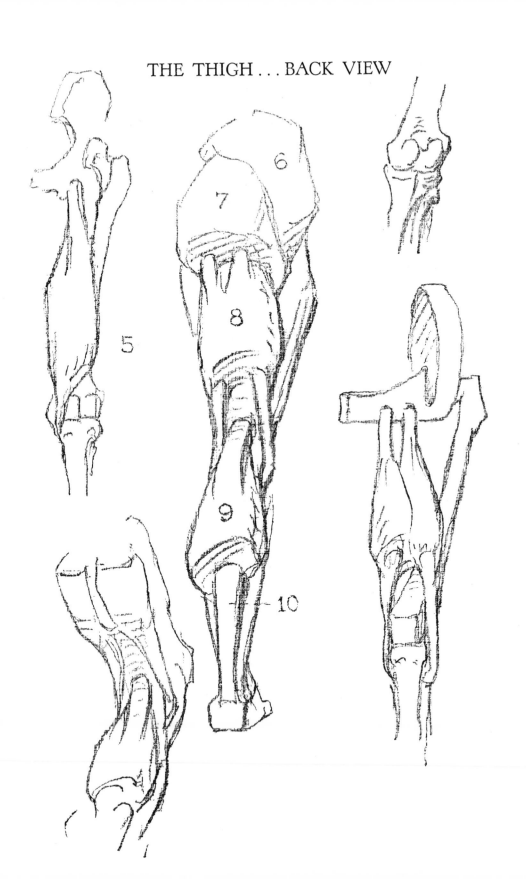

THE KNEE

KNEE BONES
SIDE VIEW

LATERAL
LIGAMEN

CAPSULE
OF KNEE

LUBRICATING
SYSTEM

THE KNEE

IS OILED

THE PATELLA

KNEE CAP

SIDE VIEW
RESEMBLES

A COLLAR
BUTTON

THE KNEE

ARTICULATION OF THE KNEE BONES

THE PATELLA ACTS AS A PULLEY

FIBROUS CAPSULE COVERING THE KNEE

THE THIGH AND LEC BONES
GLIDE ON ONE ANOTHER

THE KNEE BONES BACK VIEW

I

1
2
3
4
5

II

1
2
3

III

IV

BONES: I

1. The thigh bone, the femur, artic-ulates with the leg bone, (the tibia at the knee).

2. There is an internal and external tuberosity on each side of the thigh bone at the knee. The inner is the most prominent.

3. The patella is a small disk of bone that plays the part of a pulley in front of the lower end of the femur, called the kneecap.

4. The leg like the forearm is com-posed of two bones. The larger of the two is the tibia.

5. The fibula is flute like in length and thickness. It is placed on the outer side of the tibia.

MUSCLES: II

Three surface muscles make up the extensors of the leg. They are united by a tendon to the patella, then con-tinue to the tibia by a ligament. These muscles end a short distance above the knee, forming three divisions as they join the common tendon.

1. The rectus muscle at its lower margin joins the common tendon quite high above the knee.

2. The vastus externus occupies the outer side of the thigh above the knee. There its fibres pass by a flat tendon into this common tendon that goes to the patella.

3. The vastus internus terminates as a mass lower down than either of the preceding muscles. It is inserted by a tendon to the patella on the inner side of the knee.

III

The bones of the knee move back-ward and forward in the same plane for which a hinge joint is sufficient. Bands of tendons and ligaments tie the two shafts together. The powerful tendons that move the leg forward, pass into and around the patella that acts as a pulley to their insertion by a ligament into the tubercle of the tibia.

IV

The masses of the knee must be thought as a square or keystone in shape. The sides of which are beveled forward. All three muscular divisions above the knee are of different heights due to their lengths of tendon as they approach the kneecap, and are used as a landmark to locate the patella.

When the weight of the body rests upon the knee there is a bulge on either side of the ligament that passes from the kneecap to the leg. This bursa or water mattress is part of the lubricat-ing system of the knee.

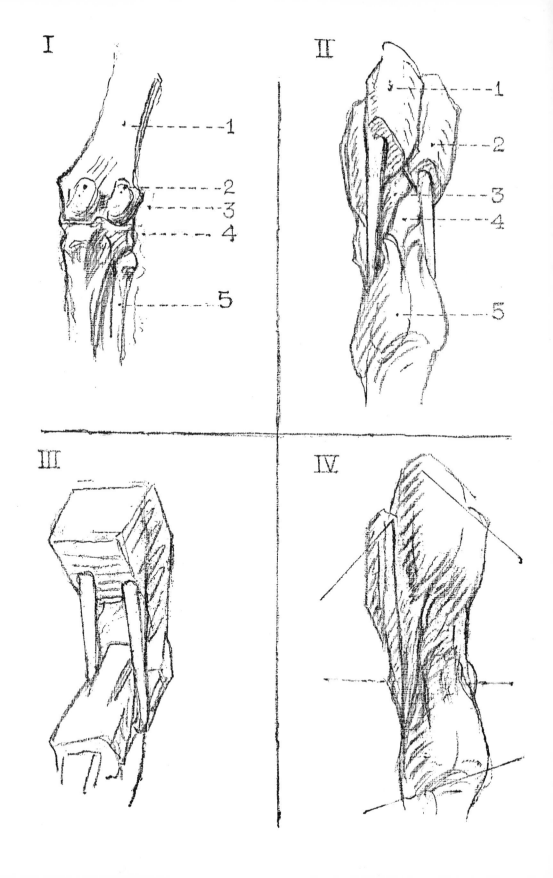

I

1
2
3
4
5

II

1
2
3
4
5

III

IV

BONES: I

1. Shaft of the femur.

2. From the back, the lower end of the femur shows two spool like prominences. These are known as the internal and external condyles.

3. The outer tuberosity of the femur.

4. The outer tuberosity of the tibia.

5. The fibula.

MUSCLES: II

1. The semi-tendinosus muscle tapers downward from the pelvis by a long tendon to be inserted into the upper part of the inner surface of the tibia at the knee.

2. The termination of the great muscles of the thigh pass round the knee to be inserted into the inner and outer sides of the leg. On the outer side, the tendon of the biceps femoris attaches to the head of the fibula with an expansion of the tendon to the tibia.

3. The semi-membranosus descends from the pelvis to the back of the inner tuberosity of the tibia. The fleshy part of the muscle descends to a lower level than the other two hamstring muscles.

4. When the leg is straight, the bones of the thigh and the leg at the back of the knee are seen on the surface. When the leg is bent, it is hollowed out. This depression is termed the popliteal space.

5. The gastrocnemius:
 (see leg.)

III

The leg has its motion at the knee. In standing, the whole weight of the body presses on the tuberosities of the thigh bones, which articulate with those of the leg. As the muscles contract, the leg is drawn up and flexed upon the thigh. As the muscles of the arm pull the forearm toward the shoulder, so the hamstrings of the thigh pull the leg upward toward the thigh.

IV

The muscular parts of the thigh above are well rounded. As they descend toward the knee, they become tendinous, the bony mass showing front, sides and back. Both the hamstrings, the semi-tendinosus and semi-membranosus pass to the inner side of the leg. They flex the knee and rotate the leg inward. The (biceps femoris,) the outer hamstring, flexes and rotates the thigh outward.

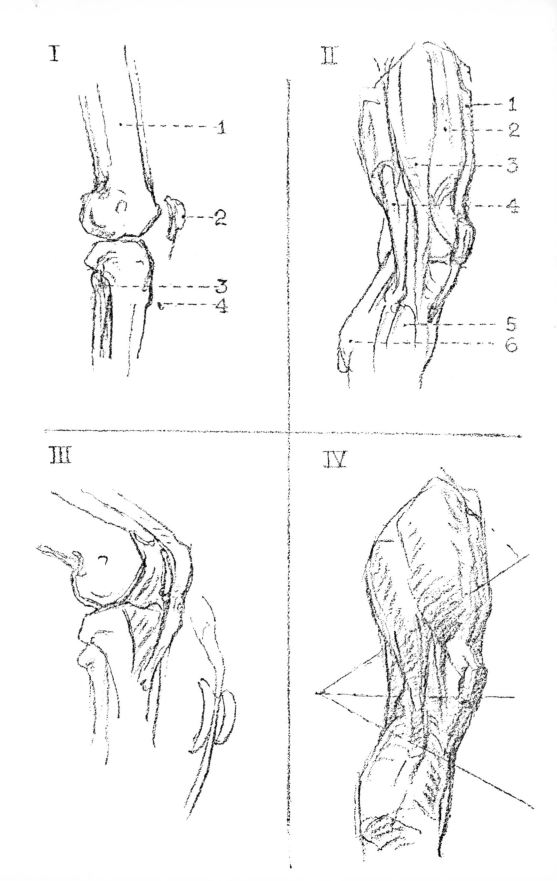

I

1
2
3
4

II

1
2
3
4

5
6

III

IV

BONES: I

1. The thigh bone ends below at the knee. When standing erect its tuberosities rest on the upper surface of the tibia. When the leg is carried backwards, the rounded ends of the femur glide in two furrows of the cartilage that are placed on the head of the tibia.

2. Patella: a small disc of bone. Its lower border is on a level with the head of the tibia.

3. Head of the fibula.

4. Tubercle of the tibia.

MUSCLES: II

1. Rectus femoris, extends the leg.

2. Vastus externus, extends and rotates the leg.

3. The ilio tibial band, rotates the thigh inward.

4. The biceps.

5. The tibialis anticus.

6. The Gastrocnemius.

III

Every joint is strictly mechanical. The so-called hinge joint at the knee is held together by strong ligaments that cross each other in such a manner as to secure the joint from any great side strain. It is also held in place by two other ligaments. These are called the lateral ligaments. There is one on either side. To keep the joint secure, there is also a parchment like membrane that is inserted round the bones of the knee. A little way above and below the knee joint, this membrane ties and holds the ends of the bones together. This surrounding membrane is flexible enough to allow the thigh and leg ample movement in the one plane.

IV

A section at the knee if frozen and cut across horizontally, would resemble a keystone in shape. It is wide at the sides toward the back, and narrower in front. The head of the leg bone (the tibia), is at a right angle to its shaft. Externally the vastus externus muscle flares outward. Below the calf of the leg, there is an outward trend leaving the outside of the knee as a flattened sunken plane.

The knee consists of bone and tendons. The muscles lie above and below the joint. Muscles are anchored at both ends either by a tendon or an aponeurosis. They conduct the muscular power to the part of the skeleton that is to be moved. Tendons are not twisted fibres like the parallel fibres of a rope. Tendons are a web of interwoven tissue.

I

1

2
3

4

II

1
2
3

4

III

IV

BONES: I

At the knee, two bones, the femur and the tibia, articulate as a hinge joint. They allow the bending and the straightening of the two lower limbs. In front, the patella or knee cup acts as a pulley.

1. The shaft of the thigh bone (the femur).

2. The lower end of the femur, its inner tuberosity.

3. The patella.

4. The tibia.

MUSCLES: II

1. The vastus internus is attached to the patella by a tendon. Its lower margin sweeps round the inner side of the knee as a bulky mass of muscle. Its attachment to the common tendon is near vertical. The lower border is directed horizontally inward to about half way on the patella.

2. The sartorius is the longest muscle in the human body, arising from above at the iliac spine of the pelvis. It descends obliquely toward the inside of the knee to be inserted to the upper and internal surface of the tibia.

3. The gracilis descends from the pelvis to the tibia. It is placed on the inner side of the thigh, where it passes round the inner side of the femur and follows the same curve as the sartorius at the knee to be inserted into the inner and upper surface of the tibia.

4. The semi-tendinosus arises from the latter part of the pelvis. It then passes round the inner side of the femur and follows the same curve as the sartorius and gracilis at the knee to be inserted into the inner and upper surface of the tibia.

III

The sartorius flexes, abducts and rotates the thigh inwards. The semi-tendinosus and gracilis both flex and abduct the leg and helps rotate it inwards.

IV

The knee, from the front, the back, or from the side must be envisioned as a square form slightly more narrow in front than at the back. The inner side of the knee is larger than the outer side. The patella is on a level with the upper border of the tibia. The vastus internus terminates by a tendon a little above halfway up the patella. The inner hamstrings and the sartorius are fixed points to watch out for. The only surface form that differs in different knees, is due to the lubricating system, that surrounds the joint.

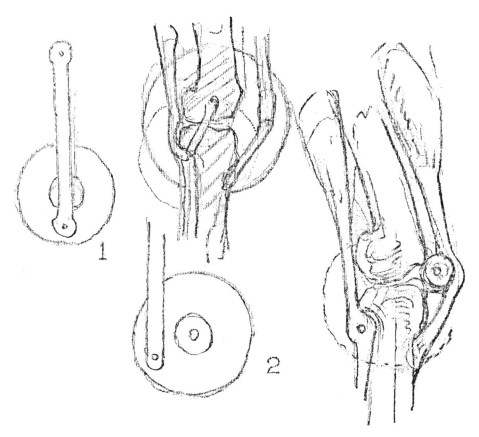

1. Mechanical dead center. 2. Off center.

There are no dead centers in the mechanism of the human body. All levers are set in such a way that a fly wheel is not necessary to carry the momentum over a dead center.

MECHANISM OF THE KNEE

The patella or knee pan in form, is unlike any other bone in the body. It lies upon the front of the knee. By powerful tendons that pass into and around it, the leg is brought forward. The patella protects both the tendon and the joint from injury and acts as a pulley in straightening out the limb. It is a part of the powerful tendons by which the leg is brought forward from their origin in the thigh to their insertion in the leg. The patella protects the tendon and the knee joint. It also gives these tendons a great mechanical advantage by altering the line of their direction, by advancing them further out from the center of motion. Many forms of machinery are rigged in the same way.

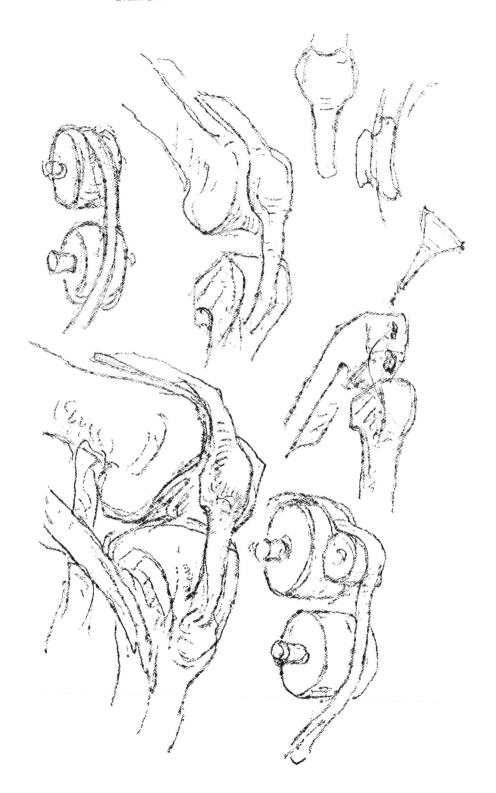

I

1
2
3
4

II

1
2
3

III

IV

LEG ... FRONT VIEW

BONES: I

1. The patella or knee pan is disc like in shape. It lies on the front of the knee.

2. Tubercle of the tibia.

3. The leg is composed of two bones. The larger of the two is the tibia and is placed on the inner side. Two tuberosities mark the inner and outer borders. Above, it connects with the lower end of the femur, and takes a direct part in the articulation of the knee. The lower and inner side of the tibia terminates in an enlarged projection at the bend of the ankle, called the internal malleolus.

4. The fibula and tibia are placed parallel to each other. The fibula is on the outside and is a long and slender bone. Above its head lies next to the tibia; below it marks the outside ankle and is known as the external malleolus. The internal and external malleolus differs from the horizontal. The external is much lower than the internal.

MUSCLES: II

1. The tibialis anticus arises from the outer surface of the tibia. It descends obliquely as a fleshy body and becomes more narrow in its descent. At the lower third, it is replaced by a long tendon, which after passing beneath the annular ligament, crosses the angle to be inserted into the base of the foot on the big toe side.

2. Peroneus, longus and brevis both arise from the shaft of the fibula. Half way down the leg they continue as a tendon which passes round the outer ankle and cross to the outer border of the foot which they help to extend.

3. The extensor longus digitorum: from both tibia and fibula, passes through the annular ligament then divides into four slips to be inserted into the four outer toes.

III

All muscles just named have their origin in the leg and terminate in the foot. The tibialis anticus flexes the ankle and raises the inner side of the foot. The peroneus and pollicis muscles turns and extends the foot, while the extensor digitorum extends the toes.

IV

A straight line across the head of the tibia marks the right angle to the tibia bone. The ridge at the shin bone descends in a curve to the ankle. The mass of the extensors follow the bone on the outer side making a curvature about a third of the way down. They then become a flattened plane as the mass approach the ankle.

I

1
2
3
4

II

1
2
3
4

III

IV

BONES: I

1. The femur.

2. At the back of the knee there are two large prominences or knobs. Thy come in contact with the upper surface of the tibia when the leg is bent. They are the inner and outer condyles.

3. The tibia is the large bone of the leg. Its upper and lower extremities widen out. The upper extremities articulate with the thigh bone. The lower extremities with the foot.

4. The fibula is placed on the outer side of the leg. Its head is near the knee. Its lower extremity is on the outer side of the foot at the ankle.

MUSCLES: II

1. The plantaris is a small muscle arising from above on the outer tuberosity of the femur, to join the tendon of the heel below.

2. The muscles at the back of the leg, by connection with the achilles tendon raise the heel. The bulk of the calf of the leg is made up of twin muscles, named the gastrocnemius and soleus. The gastrocnemius arises on the femur, just above the condyles. The soleus arises from both the tibia and the fibula, and are inserted into the tendon achilles and continued to the heel.

3. The achilles tendon is broad above where it receives the muscles of the calf of the leg. It then tapers as it descends toward the heel.

4. The soleus lies under the gastrocnemius. It arises from the back of both the tibia and the fibula. Lower down it joins the achilles tendon. It is seen on both sides of the calf of the leg.

III

Motion is performed by muscles and their tendons. To draw the heel up and drop the front part of the foot, the muscular engines are represented by the gastrocnemius and the soleus. The long tendon of the achilles is the piston cord and the heel the crank pin. As the heel rises, the muscles shorten and gain power. To raise the heel, the muscles at the back of the leg go into reverse action. The muscles that lie in front of the leg are then brought into play.

IV

The leg at the calf becomes prominent as an ovoid fleshy body. The external portion of the calf of the leg is usually a little higher than the inner portion. From here the flattened tendon descends to the heel. The soleus is seen as a ridge on either side of the calf. Its tendon is even more prominent when the leg is under tension.

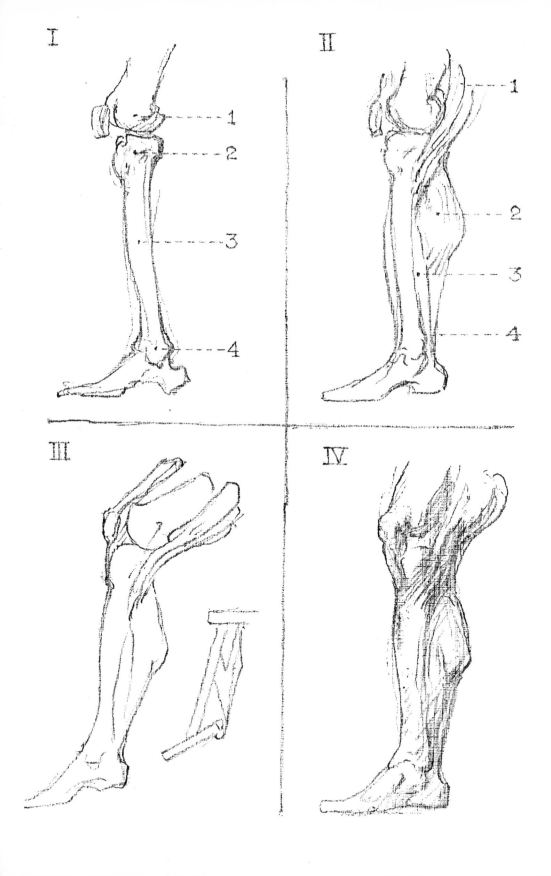

BONES: I

1. The internal tuberosity of the femur.
2. The internal tuberosity of the tibia.
3. The tibia or shin bone.
4. The malleolus internus or inner ankle.

MUSCLES: II

1. Wrapping round the internal tuberosity of the femur and the tuberosity of the tibia, are the tendons of the inner hamstring muscles. These muscles have their origin on the pelvic bone and are inserted into the inner surface of the tibia just below the knee.

2. The gastrocnemius muscle arises from two heads just above the condyles of the femur and ends below to join the broad tendon of the tendon achilles and is known as the calf of the leg.

3. The soleus is a broad flat muscle that arises from the back of the tibia and fibula and joins the tendons of the gastrocnemius. It is inserted below by fibres into the achilles tendon, thence to the oscalcis or heel bone.

4. The achilles tendon.

III

The calf of the leg is made up by the mass of the two muscles above mentioned. The principal one, the gastrocnemius is divided at its attachment above to the femur. It widens out as it descends into a single muscle where it joins the achilles tendon. At this point, the external side of the gastrocnemius is a little higher than the internal side. The flat soleus that underlies the gastrocnemius projects on each side of the calf of the leg. These lateral ridges become more prominent when the heel is raised. The hamstrings bend the knee, the calf muscles and their tendons extend the foot. The heel is the crank pin on which these muscles act to bring the foot in a straight line with the leg.

The triceps of the femur in front and the hamstrings behind have their attachments below the knee. The first group straightens the leg, while the second group bends the leg. The gastrocnemius and soleus by their attachment to the tendon of the achilles, pulls the heel up. As the heel is raised, it becomes more horizontal and nearer a right angle to the tendon, thus giving a greater leverage and more power to the foot.

IV

The inside of the leg at the knee is larger than the external side. The femur and the tibia protrude and as a whole bends convex toward its fellow. The shaft of the thigh bone is carried some distance out by a long neck so that the thigh is set at an angle with the leg.

I

1
2
3
4

II

1
2
3
4
5

III

IV

BONES: I

1. The femur.
2. The knee cap, (patella).
3. The head of the fibula.
4. The tibia.

MUSCLES: II

1. The biceps femoris muscle is inserted to the outer side of the knee by a tendon that is attached to the head of the fibula.

2. Proneus longus, from the shaft of the fibula, terminating in a long tendon that passes down the outer surface of the leg to the outer ankle where it joins the proneus brevis, to be inserted into the outer border of the foot.

3. The tibialis anticus arises from the outer surface of the tibia near the outer tuberosity. Its fleshy portion extends from above, to about the lower third of the leg passing from there as a tendon through the annular ligament to be inserted into the base of the big toe.

4. The gastrocnemius, known as the calf of the leg.

5. The extensor of the toes, (the longus digitorum), arises from both tibia and fibula. The tendons of this muscle are divided into four divisions after passing under a ligament at the ankle, to be inserted into the four outer toes.

III

The thigh bone and the leg bone at the knee (acts as a hinge), and is the largest joint in the body. Its security and strength depends on the lateral ligaments and the tendons of those muscles which pass over it. A membrane also ties and confines the ends of the bones together, keeping the parts of the joint in close application to each other.

When standing erect, the tendons and ligaments at the front of the knee are not under tension, the knee cap is not fixed under these conditions, but quite loose. All the muscles and tendons below the knee move the foot. The gastrocnemius and soleus act on the foot raising the heel, while the tibialis and peroneus turns or rotates the foot at the ankle joint.

IV

The outer view of the thigh sinks in at the knee giving a concave curvature from the mass above. Below, the leg curves downward and outward to the curve of the calf. The tibia and fibula are seen as flattened planes front and side.

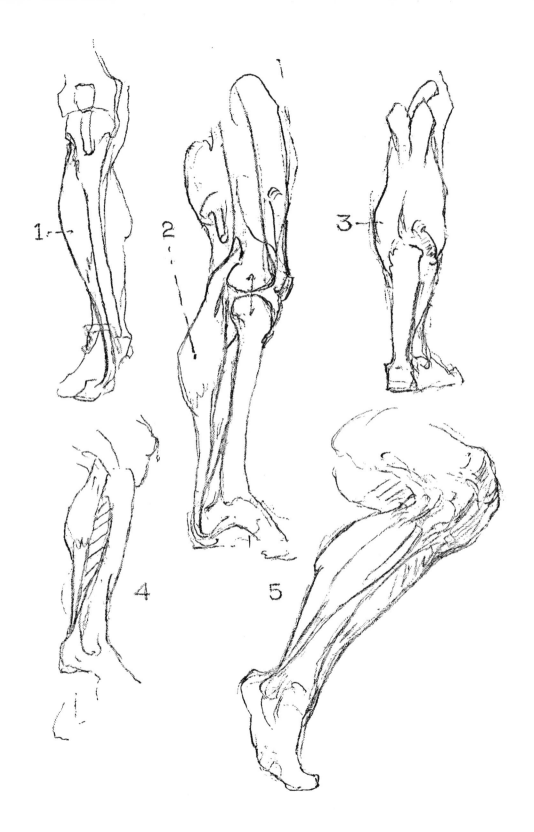

1....The tibialis anticus is a rounded muscle that arises from the tibia just below the knee. It passes down the outer side of the shin bone. Below its tendon passes through a band at the ankle, the annular ligament, and is inserted into the base of the great toe. Its lateral movement turns and elevates the inner border of the foot.

2......Viewed from the side, the tendinous portion of the gastroc-nemius is seen gripping the shaft of the femur just above the condyles. The soleus arises from the back of the tibia and fibula then passes back-ward to join that of the gastrocnemius; both are inserted into the heel bone by the tendon achilles.

3....The inner portion of the gastrocnemius where it joins the achilles tendon, is set at a lower level than the outer division. The soleus shows on both sides of the calf beyond the inner and outer margins of the gastrocnemius.

4....The soleus is a broad flat muscle, shaped like a sole fish. It arises from back of the tibia and fibula. The lower part joins the ten-don of the achilles.

5....The leg (see figure 5) shows the arrangement of muscles in rotation, seen from the fibular side. First, the gastrocnemius. Second, the soleus. Third, the peroneus longus and brevis, and the tibialis anticus. The extensors of the toes are more to the front.

The upper end of the calf of the leg is fixed firmly to the lower end of the thigh bone just above the condyles of the femur, while the soleus which lies directly beneath, is fastened to the back of the leg bones, (the tibia and fibula).

The two are connected by a strong tendon to the heel bone. This tendon acts as a connecting rod to the heel which may be likened to a crank pin on which the muscles at the back of the leg may raise the heel and presses the front part of the foot to the ground. Then the muscles that are placed on the front of the leg come into action. These muscles are furnished with long tendons that pass from the foot to the toes. These tendons do not have the power of the muscles that raise the heel, but act as a break in easing the front part of the foot to the ground as well as raising the toes.

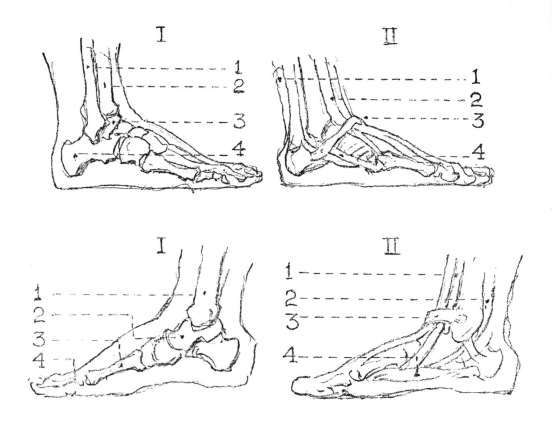

BONES AND MUSCLES OF THE FOOT

BONES: I OUTER SIDE

1. The fibula.
2. The tibia.
3. The astragalus.
4. The oscalcis.

BONES: I INNER SIDE

1. The tibia.
2. The astragalus.
3. The metatarsal.
4. The phalanges.

MUSCLES: II OUTER SIDE

1. The tendon achilis.
2. The extensor of the toes.
3. The annular ligament.
4. The peroneus.

MUSCLES: II INNER SIDE

1. The tibialis anticus.
2. The flexor policis.
3. The annular ligament.
4. The abductor policis.

THE FOOT

The bones of the foot are arched. At their summit is a keystone upon which the weight of the body is poised. The two bones of the leg are called the tibia and fibula. Between the extermities of these two bones, articulates the astragalus. When the foot is raised, as in stepping forward, it rolls easily on the arch that is placed between the two bones of the leg. These extermities are known as the inner and outer ankles.

When the foot is flat or planted, and the body is carried forward, the joint of the leg and foot become a fixed and steady base to rest upon. In walking, the heel first touches the ground and the foot descends in a semicircle, the center of which is the heel.

The arch of the foot is composed of twenty-six bones which not only permits motion, but allows great elasticity. The arch of the foot has requisite strength to support the weight of the body as well as additional burden.

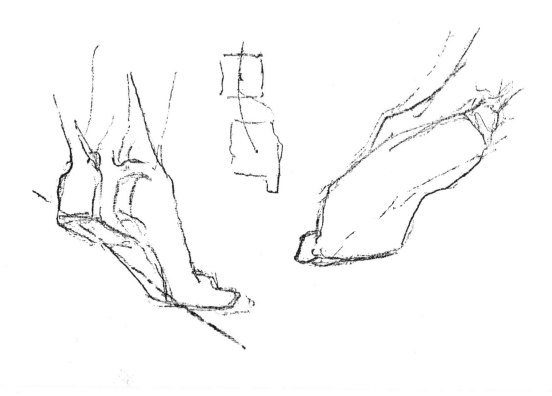

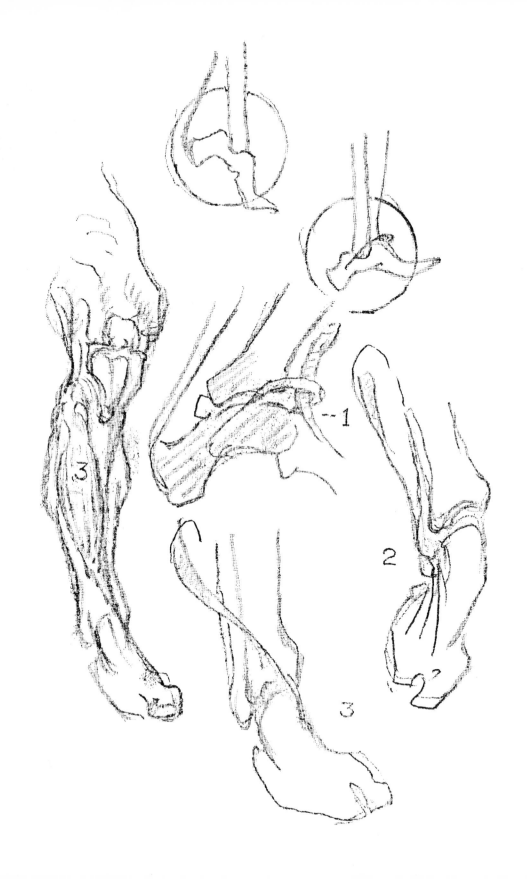

ABDUCTION AND ADDUCTION

When turning the foot inward toward the body it is called adduction. Abduction means turning away. Abduction and adduction is controlled by the tendons that pass round the inner and outer ankles. The tendons that pass round the outer ankle bone pull the foot in an outward direction. The tendons that pass round the inner ankle bone turn the foot in. The foot is also capable of turning and elevating its inner border. The muscle that causes this movement passes from the outer to the inner side of the leg. The tendon passes over the arch of the foot to the base of the metatarsal of the great toe and is called the tibialis anticus. ·

1....The extensors as they pass under the annular ligament.

2....Tendons of both the long and short peroneals pass round the outer ankle to the outer side of the foot.

3....The tibialis anticus passes in front of the inner ankle to be inserted into the base of the great toe.

THE FOOT AND THE TOES

The arch of the foot is curved from heel to toe. The arch plays freely between two bones, the inner and outer ankle. From the two ends of this arch at its base, a strong elastic ligament extends that sinks or rises as the weight of the body bears upon the arch. The foot is also arched from side to side as well as forward, across and horizontally. The bones of the foot are wedged together and bound by ligaments. The leg bones rest on the arch where it articulates with the astragalus, the key-bone or keystone of the arch. This keystone is not fixed as in masonry, it moves freely between the inner and outer condyle. The heel is on the outside of the foot. The ball of the large toe on the inside giving it the rotary and transverse movement already mentioned.

Toes are placed on the top of the foot and descend downward by steps tending to keep flat on the ground. The little toe is an exception. The big toe, as well as the little toe, has but two steps down. The other toes have three steps to reach the ground.

The mechanical contrivance used to move the toes, is a slit in one tendon to let another tendon pass through it. A long tendon in the foot bends the first joint of the toe and passes through the short tendon which bends the second joint.

The foot has strength to support the weight of the body. It also has flexibility, elasticity and beauty of form. Its construction is the envy of the bridge builders. The arrangement of its tendons and ligaments as they bind, pass round and through slits is akin with the belts, straps and ropes of the machine age of today.

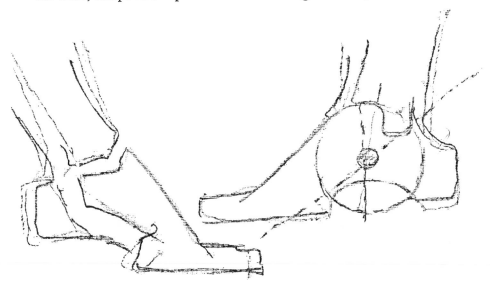

A CATALOG OF SELECTED
DOVER BOOKS
IN ALL FIELDS OF INTEREST

A CATALOG OF SELECTED DOVER
BOOKS IN ALL FIELDS OF INTEREST

CONCERNING THE SPIRITUAL IN ART, Wassily Kandinsky. Pioneering work by father of abstract art. Thoughts on color theory, nature of art. Analysis of earlier masters. 12 illustrations. 80pp. of text. 5⅜ × 8½. 23411-8 Pa. $3.95

ANIMALS: 1,419 Copyright-Free Illustrations of Mammals, Birds, Fish, Insects, etc., Jim Harter (ed.). Clear wood engravings present, in extremely lifelike poses, over 1,000 species of animals. One of the most extensive pictorial sourcebooks of its kind. Captions. Index. 284pp. 9 × 12. 23766-4 Pa. $11.95

CELTIC ART: The Methods of Construction, George Bain. Simple geometric techniques for making Celtic interlacements, spirals, Kells-type initials, animals, humans, etc. Over 500 illustrations. 160pp. 9 × 12. (USO) 22923-8 Pa. $8.95

AN ATLAS OF ANATOMY FOR ARTISTS, Fritz Schider. Most thorough reference work on art anatomy in the world. Hundreds of illustrations, including selections from works by Vesalius, Leonardo, Goya, Ingres, Michelangelo, others. 593 illustrations. 192pp. 7⅛ × 10¼. 20241-0 Pa. $8.95

CELTIC HAND STROKE-BY-STROKE (Irish Half-Uncial from "The Book of Kells"): An Arthur Baker Calligraphy Manual, Arthur Baker. Complete guide to creating each letter of the alphabet in distinctive Celtic manner. Covers hand position, strokes, pens, inks, paper, more. Illustrated. 48pp. 8¼ × 11.

24336-2 Pa. $3.95

EASY ORIGAMI, John Montroll. Charming collection of 32 projects (hat, cup, pelican, piano, swan, many more) specially designed for the novice origami hobbyist. Clearly illustrated easy-to-follow instructions insure that even beginning papercrafters will achieve successful results. 48pp. 8¼ × 11. 27298-2 Pa. $2.95

THE COMPLETE BOOK OF BIRDHOUSE CONSTRUCTION FOR WOOD-WORKERS, Scott D. Campbell. Detailed instructions, illustrations, tables. Also data on bird habitat and instinct patterns. Bibliography. 3 tables. 63 illustrations in 15 figures. 48pp. 5¼ × 8½. 24407-5 Pa. $1.95

BLOOMINGDALE'S ILLUSTRATED 1886 CATALOG: Fashions, Dry Goods and Housewares, Bloomingdale Brothers. Famed merchants' extremely rare catalog depicting about 1,700 products: clothing, housewares, firearms, dry goods, jewelry, more. Invaluable for dating, identifying vintage items. Also, copyright-free graphics for artists, designers. Co-published with Henry Ford Museum & Green-field Village. 160pp. 8¼ × 11. 25780-0 Pa. $9.95

HISTORIC COSTUME IN PICTURES, Braun & Schneider. Over 1,450 costumed figures in clearly detailed engravings—from dawn of civilization to end of 19th century. Captions. Many folk costumes. 256pp. 8⅜ × 11¾. 23150-X Pa. $10.95

BRASS INSTRUMENTS: Their History and Development, Anthony Baines. Authoritative, updated survey of the evolution of trumpets, trombones, bugles, cornets, French horns, tubas and other brass wind instruments. Over 140 illustrations and 48 music examples. Corrected and updated by author. New preface. Bibliography. 320pp. 5⅜ × 8½. 27574-4 Pa. $9.95

HOLLYWOOD GLAMOR PORTRAITS, John Kobal (ed.). 145 photos from 1926–49. Harlow, Gable, Bogart, Bacall; 94 stars in all. Full background on photographers, technical aspects. 160pp. 8⅜ × 11¼. 23352-9 Pa. $9.95

MAX AND MORITZ, Wilhelm Busch. Great humor classic in both German and English. Also 10 other works: "Cat and Mouse," "Plisch and Plumm," etc. 216pp. 5⅜ × 8½. 20181-3 Pa. $5.95

THE RAVEN AND OTHER FAVORITE POEMS, Edgar Allan Poe. Over 40 of the author's most memorable poems: "The Bells," "Ulalume," "Israfel," "To Helen," "The Conqueror Worm," "Eldorado," "Annabel Lee," many more. Alphabetic lists of titles and first lines. 64pp. 5³⁄₁₆ × 8¼. 26685-0 Pa. $1.00

SEVEN SCIENCE FICTION NOVELS, H. G. Wells. The standard collection of the great novels. Complete, unabridged. First Men in the Moon, Island of Dr. Moreau, War of the Worlds, Food of the Gods, Invisible Man, Time Machine, In the Days of the Comet. Total of 1,015pp. 5⅜ × 8½. (USO) 20264-X Clothbd. $29.95

AMULETS AND SUPERSTITIONS, E. A. Wallis Budge. Comprehensive discourse on origin, powers of amulets in many ancient cultures: Arab, Persian, Babylonian, Assyrian, Egyptian, Gnostic, Hebrew, Phoenician, Syriac, etc. Covers cross, swastika, crucifix, seals, rings, stones, etc. 584pp. 5⅜ × 8½. 23573-4 Pa. $12.95

RUSSIAN STORIES/PYCCKNE PACCKA3bl: A Dual-Language Book, edited by Gleb Struve. Twelve tales by such masters as Chekhov, Tolstoy, Dostoevsky, Pushkin, others. Excellent word-for-word English translations on facing pages, plus teaching and study aids, Russian/English vocabulary, biographical/critical introductions, more. 416pp. 5⅜ × 8½. 26244-8 Pa. $8.95

PHILADELPHIA THEN AND NOW: 60 Sites Photographed in the Past and Present, Kenneth Finkel and Susan Oyama. Rare photographs of City Hall, Logan Square, Independence Hall, Betsy Ross House, other landmarks juxtaposed with contemporary views. Captures changing face of historic city. Introduction. Captions. 128pp. 8¼ × 11. 25790-8 Pa. $9.95

AIA ARCHITECTURAL GUIDE TO NASSAU AND SUFFOLK COUNTIES, LONG ISLAND, The American Institute of Architects, Long Island Chapter, and the Society for the Preservation of Long Island Antiquities. Comprehensive, well-researched and generously illustrated volume brings to life over three centuries of Long Island's great architectural heritage. More than 240 photographs with authoritative, extensively detailed captions. 176pp. 8¼ × 11. 26946-9 Pa. $14.95

NORTH AMERICAN INDIAN LIFE: Customs and Traditions of 23 Tribes, Elsie Clews Parsons (ed.). 27 fictionalized essays by noted anthropologists examine religion, customs, government, additional facets of life among the Winnebago, Crow, Zuni, Eskimo, other tribes. 480pp. 6⅛ × 9¼. 27377-6 Pa. $10.95

THE BEST TALES OF HOFFMANN, E. T. A. Hoffmann. 10 of Hoffmann's most important stories: "Nutcracker and the King of Mice," "The Golden Flowerpot," etc. 458pp. 5⅜ × 8½. 21793-0 Pa. $8.95

FROM FETISH TO GOD IN ANCIENT EGYPT, E. A. Wallis Budge. Rich detailed survey of Egyptian conception of "God" and gods, magic, cult of animals, Osiris, more. Also, superb English translations of hymns and legends. 240 illustrations. 545pp. 5⅜ × 8½. 25803-3 Pa. $11.95

FRENCH STORIES/CONTES FRANÇAIS: A Dual-Language Book, Wallace Fowlie. Ten stories by French masters, Voltaire to Camus: "Micromegas" by Voltaire; "The Atheist's Mass" by Balzac; "Minuet" by de Maupassant; "The Guest" by Camus, six more. Excellent English translations on facing pages. Also French-English vocabulary list, exercises, more. 352pp. 5⅜ × 8½. 26443-2 Pa. $8.95

CHICAGO AT THE TURN OF THE CENTURY IN PHOTOGRAPHS: 122 Historic Views from the Collections of the Chicago Historical Society, Larry A. Viskochil. Rare large-format prints offer detailed views of City Hall, State Street, the Loop, Hull House, Union Station, many other landmarks, circa 1904-1913. Introduction. Captions. Maps. 144pp. 9⅜ × 12¼. 24656-6 Pa. $12.95

OLD BROOKLYN IN EARLY PHOTOGRAPHS, 1865-1929, William Lee Younger. Luna Park, Gravesend race track, construction of Grand Army Plaza, moving of Hotel Brighton, etc. 157 previously unpublished photographs. 165pp. 8⅞ × 11¾. 23587-4 Pa. $12.95

THE MYTHS OF THE NORTH AMERICAN INDIANS, Lewis Spence. Rich anthology of the myths and legends of the Algonquins, Iroquois, Pawnees and Sioux, prefaced by an extensive historical and ethnological commentary. 36 illustrations. 480pp. 5⅜ × 8½. 25967-6 Pa. $8.95

AN ENCYCLOPEDIA OF BATTLES: Accounts of Over 1,560 Battles from 1479 B.C. to the Present, David Eggenberger. Essential details of every major battle in recorded history from the first battle of Megiddo in 1479 B.C. to Grenada in 1984. List of Battle Maps. New Appendix covering the years 1967-1984. Index. 99 illustrations. 544pp. 6½ × 9¼. 24913-1 Pa. $14.95

SAILING ALONE AROUND THE WORLD, Captain Joshua Slocum. First man to sail around the world, alone, in small boat. One of great feats of seamanship told in delightful manner. 67 illustrations. 294pp. 5⅜ × 8½. 20326-3 Pa. $5.95

ANARCHISM AND OTHER ESSAYS, Emma Goldman. Powerful, penetrating, prophetic essays on direct action, role of minorities, prison reform, puritan hypocrisy, violence, etc. 271pp. 5⅜ × 8½. 22484-8 Pa. $5.95

MYTHS OF THE HINDUS AND BUDDHISTS, Ananda K. Coomaraswamy and Sister Nivedita. Great stories of the epics; deeds of Krishna, Shiva, taken from puranas, Vedas, folk tales; etc. 32 illustrations. 400pp. 5⅜ × 8½. 21759-0 Pa. $9.95

BEYOND PSYCHOLOGY, Otto Rank. Fear of death, desire of immortality, nature of sexuality, social organization, creativity, according to Rankian system. 291pp. 5⅜ × 8½. 20485-5 Pa. $7.95

A THEOLOGICO-POLITICAL TREATISE, Benedict Spinoza. Also contains unfinished Political Treatise. Great classic on religious liberty, theory of government on common consent. R. Elwes translation. Total of 421pp. 5⅜ × 8½. 20249-6 Pa. $7.95

PERSPECTIVE FOR ARTISTS, Rex Vicat Cole. Depth, perspective of sky and sea, shadows, much more, not usually covered. 391 diagrams, 81 reproductions of drawings and paintings. 279pp. 5⅜ × 8½. 22487-2 Pa. $6.95

DRAWING THE LIVING FIGURE, Joseph Sheppard. Innovative approach to artistic anatomy focuses on specifics of surface anatomy, rather than muscles and bones. Over 170 drawings of live models in front, back and side views, and in widely varying poses. Accompanying diagrams. 177 illustrations. Introduction. Index. 144pp. 8⅜ × 11¼. 26723-7 Pa. $7.95

GOTHIC AND OLD ENGLISH ALPHABETS: 100 Complete Fonts, Dan X. Solo. Add power, elegance to posters, signs, other graphics with 100 stunning copyright-free alphabets: Blackstone, Dolbey, Germania, 97 more—including many lower-case, numerals, punctuation marks. 104pp. 8⅛ × 11. 24695-7 Pa. $7.95

HOW TO DO BEADWORK, Mary White. Fundamental book on craft from simple projects to five-bead chains and woven works. 106 illustrations. 142pp. 5⅜ × 8. 20697-1 Pa. $4.95

THE BOOK OF WOOD CARVING, Charles Marshall Sayers. Finest book for beginners discusses fundamentals and offers 34 designs. "Absolutely first rate . . . well thought out and well executed."—E. J. Tangerman. 118pp. 7¾ × 10⅝. 23654-4 Pa. $5.95

ILLUSTRATED CATALOG OF CIVIL WAR MILITARY GOODS: Union Army Weapons, Insignia, Uniform Accessories, and Other Equipment, Schuyler, Hartley, and Graham. Rare, profusely illustrated 1846 catalog includes Union Army uniform and dress regulations, arms and ammunition, coats, insignia, flags, swords, rifles, etc. 226 illustrations. 160pp. 9 × 12. 24939-5 Pa. $10.95

WOMEN'S FASHIONS OF THE EARLY 1900s: An Unabridged Republication of "New York Fashions, 1909," National Cloak & Suit Co. Rare catalog of mail-order fashions documents women's and children's clothing styles shortly after the turn of the century. Captions offer full descriptions, prices. Invaluable resource for fashion, costume historians. Approximately 725 illustrations. 128pp. 8⅜ × 11¼. 27276-1 Pa. $10.95

THE 1912 AND 1915 GUSTAV STICKLEY FURNITURE CATALOGS, Gustav Stickley. With over 200 detailed illustrations and descriptions, these two catalogs are essential reading and reference materials and identification guides for Stickley furniture. Captions cite materials, dimensions and prices. 112pp. 6½ × 9¼. 26676-1 Pa. $9.95

EARLY AMERICAN LOCOMOTIVES, John H. White, Jr. Finest locomotive engravings from early 19th century: historical (1804–74), main-line (after 1870), special, foreign, etc. 147 plates. 142pp. 11⅜ × 8¼. 22772-3 Pa. $8.95

THE TALL SHIPS OF TODAY IN PHOTOGRAPHS, Frank O. Braynard. Lavishly illustrated tribute to nearly 100 majestic contemporary sailing vessels: Amerigo Vespucci, Clearwater, Constitution, Eagle, Mayflower, Sea Cloud, Victory, many more. Authoritative captions provide statistics, background on each ship. 190 black-and-white photographs and illustrations. Introduction. 128pp. 8⅜ × 11¼. 27163-3 Pa. $12.95

EARLY NINETEENTH-CENTURY CRAFTS AND TRADES, Peter Stockham (ed.). Extremely rare 1807 volume describes to youngsters the crafts and trades of the day: brickmaker, weaver, dressmaker, bookbinder, ropemaker, saddler, many more. Quaint prose, charming illustrations for each craft. 20 black-and-white line illustrations. 192pp. 4⅝ × 6. 27293-1 Pa. $4.95

VICTORIAN FASHIONS AND COSTUMES FROM HARPER'S BAZAR, 1867–1898, Stella Blum (ed.). Day costumes, evening wear, sports clothes, shoes, hats, other accessories in over 1,000 detailed engravings. 320pp. 9⅜ × 12¼.
22990-4 Pa. $13.95

GUSTAV STICKLEY, THE CRAFTSMAN, Mary Ann Smith. Superb study surveys broad scope of Stickley's achievement, especially in architecture. Design philosophy, rise and fall of the Craftsman empire, descriptions and floor plans for many Craftsman houses, more. 86 black-and-white halftones. 31 line illustrations. Introduction. 208pp. 6½ × 9¼. 27210-9 Pa. $9.95

THE LONG ISLAND RAIL ROAD IN EARLY PHOTOGRAPHS, Ron Ziel. Over 220 rare photos, informative text document origin (1844) and development of rail service on Long Island. Vintage views of early trains, locomotives, stations, passengers, crews, much more. Captions. 8⅞ × 11¾. 26301-0 Pa. $13.95

THE BOOK OF OLD SHIPS: From Egyptian Galleys to Clipper Ships, Henry B. Culver. Superb, authoritative history of sailing vessels, with 80 magnificent line illustrations. Galley, bark, caravel, longship, whaler, many more. Detailed, informative text on each vessel by noted naval historian. Introduction. 256pp. 5⅜ × 8½. 27332-6 Pa. $6.95

TEN BOOKS ON ARCHITECTURE, Vitruvius. The most important book ever written on architecture. Early Roman aesthetics, technology, classical orders, site selection, all other aspects. Morgan translation. 331pp. 5⅜ × 8½. 20645-9 Pa. $8.95

THE HUMAN FIGURE IN MOTION, Eadweard Muybridge. More than 4,500 stopped-action photos, in action series, showing undraped men, women, children jumping, lying down, throwing, sitting, wrestling, carrying, etc. 390pp. 7⅞ × 10⅝.
20204-6 Clothbd. $24.95

TREES OF THE EASTERN AND CENTRAL UNITED STATES AND CANADA, William M. Harlow. Best one-volume guide to 140 trees. Full descriptions, woodlore, range, etc. Over 600 illustrations. Handy size. 288pp. 4½ × 6⅜.
20395-6 Pa. $5.95

SONGS OF WESTERN BIRDS, Dr. Donald J. Borror. Complete song and call repertoire of 60 western species, including flycatchers, juncoes, cactus wrens, many more—includes fully illustrated booklet. Cassette and manual 99913-0 $8.95

GROWING AND USING HERBS AND SPICES, Milo Miloradovich. Versatile handbook provides all the information needed for cultivation and use of all the herbs and spices available in North America. 4 illustrations. Index. Glossary. 236pp. 5⅜ × 8½. 25058-X Pa. $5.95

BIG BOOK OF MAZES AND LABYRINTHS, Walter Shepherd. 50 mazes and labyrinths in all—classical, solid, ripple, and more—in one great volume. Perfect inexpensive puzzler for clever youngsters. Full solutions. 112pp. 8⅛ × 11.
22951-3 Pa. $3.95

PIANO TUNING, J. Cree Fischer. Clearest, best book for beginner, amateur. Simple repairs, raising dropped notes, tuning by easy method of flattened fifths. No previous skills needed. 4 illustrations. 201pp. 5⅜ × 8½. 23267-0 Pa. $5.95

A SOURCE BOOK IN THEATRICAL HISTORY, A. M. Nagler. Contemporary observers on acting, directing, make-up, costuming, stage props, machinery, scene design, from Ancient Greece to Chekhov. 611pp. 5⅜ × 8½. 20515-0 Pa. $11.95

THE COMPLETE NONSENSE OF EDWARD LEAR, Edward Lear. All nonsense limericks, zany alphabets, Owl and Pussycat, songs, nonsense botany, etc., illustrated by Lear. Total of 320pp. 5⅜ × 8½. (USO) 20167-8 Pa. $5.95

VICTORIAN PARLOUR POETRY: An Annotated Anthology, Michael R. Turner. 117 gems by Longfellow, Tennyson, Browning, many lesser-known poets. "The Village Blacksmith," "Curfew Must Not Ring Tonight," "Only a Baby Small," dozens more, often difficult to find elsewhere. Index of poets, titles, first lines. xxiii + 325pp. 5⅜ × 8¼. 27044-0 Pa. $8.95

DUBLINERS, James Joyce. Fifteen stories offer vivid, tightly focused observations of the lives of Dublin's poorer classes. At least one, "The Dead," is considered a masterpiece. Reprinted complete and unabridged from standard edition. 160pp. 5³⁄₁₆ × 8¼. 26870-5 Pa. $1.00

THE HAUNTED MONASTERY and THE CHINESE MAZE MURDERS, Robert van Gulik. Two full novels by van Gulik, set in 7th-century China, continue adventures of Judge Dee and his companions. An evil Taoist monastery, seemingly supernatural events; overgrown topiary maze hides strange crimes. 27 illustrations. 328pp. 5⅜ × 8½. 23502-5 Pa. $7.95

THE BOOK OF THE SACRED MAGIC OF ABRAMELIN THE MAGE, translated by S. MacGregor Mathers. Medieval manuscript of ceremonial magic. Basic document in Aleister Crowley, Golden Dawn groups. 268pp. 5⅜ × 8½. 23211-5 Pa. $7.95

NEW RUSSIAN-ENGLISH AND ENGLISH-RUSSIAN DICTIONARY, M. A. O'Brien. This is a remarkably handy Russian dictionary, containing a surprising amount of information, including over 70,000 entries. 366pp. 4½ × 6⅛. 20208-9 Pa. $8.95

HISTORIC HOMES OF THE AMERICAN PRESIDENTS, Second, Revised Edition, Irvin Haas. A traveler's guide to American Presidential homes, most open to the public, depicting and describing homes occupied by every American President from George Washington to George Bush. With visiting hours, admission charges, travel routes. 175 photographs. Index. 160pp. 8¼ × 11. 26751-2 Pa. $10.95

NEW YORK IN THE FORTIES, Andreas Feininger. 162 brilliant photographs by the well-known photographer, formerly with *Life* magazine. Commuters, shoppers, Times Square at night, much else from city at its peak. Captions by John von Hartz. 181pp. 9¼ × 10¾. 23585-8 Pa. $12.95

INDIAN SIGN LANGUAGE, William Tomkins. Over 525 signs developed by Sioux and other tribes. Written instructions and diagrams. Also 290 pictographs. 111pp. 6⅛ × 9¼. 22029-X Pa. $3.50

AUTOBIOGRAPHY: The Story of My Experiments with Truth, Mohandas K. Gandhi. Boyhood, legal studies, purification, the growth of the Satyagraha (nonviolent protest) movement. Critical, inspiring work of the man responsible for the freedom of India. 480pp. 5⅜ × 8½. (USO)　　　24593-4 Pa. $7.95

CELTIC MYTHS AND LEGENDS, T. W. Rolleston. Masterful retelling of Irish and Welsh stories and tales. Cuchulain, King Arthur, Deirdre, the Grail, many more. First paperback edition. 58 full-page illustrations. 512pp. 5⅜ × 8½.
　　　26507-2 Pa. $9.95

THE PRINCIPLES OF PSYCHOLOGY, William James. Famous long course complete, unabridged. Stream of thought, time perception, memory, experimental methods; great work decades ahead of its time. 94 figures. 1,391pp. 5⅜ × 8½. 2-vol. set.
Vol. I: 20381-6 Pa. $12.95
Vol. II: 20382-4 Pa. $12.95

THE WORLD AS WILL AND REPRESENTATION, Arthur Schopenhauer. Definitive English translation of Schopenhauer's life work, correcting more than 1,000 errors, omissions in earlier translations. Translated by E. F. J. Payne. Total of 1,269pp. 5⅜ × 8½. 2-vol. set.
Vol. 1: 21761-2 Pa. $10.95
Vol. 2: 21762-0 Pa. $11.95

MAGIC AND MYSTERY IN TIBET, Madame Alexandra David-Neel. Experiences among lamas, magicians, sages, sorcerers, Bonpa wizards. A true psychic discovery. 32 illustrations. 321pp. 5⅜ × 8½. (USO)　　　22682-4 Pa. $8.95

THE EGYPTIAN BOOK OF THE DEAD, E. A. Wallis Budge. Complete reproduction of Ani's papyrus, finest ever found. Full hieroglyphic text, interlinear transliteration, word-for-word translation, smooth translation. 533pp. 6½ × 9¼.
　　　21866-X Pa. $9.95

MATHEMATICS FOR THE NONMATHEMATICIAN, Morris Kline. Detailed, college-level treatment of mathematics in cultural and historical context, with numerous exercises. Recommended Reading Lists. Tables. Numerous figures. 641pp. 5⅜ × 8½.　　　24823-2 Pa. $11.95

THEORY OF WING SECTIONS: Including a Summary of Airfoil Data, Ira H. Abbott and A. E. von Doenhoff. Concise compilation of subsonic aerodynamic characteristics of NACA wing sections, plus description of theory. 350pp. of tables. 693pp. 5⅜ × 8½.　　　60586-8 Pa. $13.95

THE RIME OF THE ANCIENT MARINER, Gustave Doré, S. T. Coleridge. Doré's finest work; 34 plates capture moods, subtleties of poem. Flawless full-size reproductions printed on facing pages with authoritative text of poem. "Beautiful. Simply beautiful."—*Publisher's Weekly.* 77pp. 9¼ × 12.　　　22305-1 Pa. $5.95

NORTH AMERICAN INDIAN DESIGNS FOR ARTISTS AND CRAFTS-PEOPLE, Eva Wilson. Over 360 authentic copyright-free designs adapted from Navajo blankets, Hopi pottery, Sioux buffalo hides, more. Geometrics, symbolic figures, plant and animal motifs, etc. 128pp. 8⅜ × 11. (EUK)　　　25341-4 Pa. $7.95

SCULPTURE: Principles and Practice, Louis Slobodkin. Step-by-step approach to clay, plaster, metals, stone; classical and modern. 253 drawings, photos. 255pp. 8⅛ × 11.　　　22960-2 Pa. $9.95

THE INFLUENCE OF SEA POWER UPON HISTORY, 1660–1783, A. T. Mahan. Influential classic of naval history and tactics still used as text in war colleges. First paperback edition. 4 maps. 24 battle plans. 640pp. 5⅜ × 8½.
25509-3 Pa. $12.95

THE STORY OF THE TITANIC AS TOLD BY ITS SURVIVORS, Jack Winocour (ed.). What it was really like. Panic, despair, shocking inefficiency, and a little heroism. More thrilling than any fictional account. 26 illustrations. 320pp. 5⅜ × 8½.
20610-6 Pa. $7.95

FAIRY AND FOLK TALES OF THE IRISH PEASANTRY, William Butler Yeats (ed.). Treasury of 64 tales from the twilight world of Celtic myth and legend: "The Soul Cages," "The Kildare Pooka," "King O'Toole and his Goose," many more. Introduction and Notes by W. B. Yeats. 352pp. 5⅜ × 8½.
26941-8 Pa. $7.95

BUDDHIST MAHAYANA TEXTS, E. B. Cowell and Others (eds.). Superb, accurate translations of basic documents in Mahayana Buddhism, highly important in history of religions. The Buddha-karita of Asvaghosha, Larger Sukhavativyuha, more. 448pp. 5⅜ × 8½. ,
25552-2 Pa. $9.95

ONE TWO THREE . . . INFINITY: Facts and Speculations of Science, George Gamow. Great physicist's fascinating, readable overview of contemporary science: number theory, relativity, fourth dimension, entropy, genes, atomic structure, much more. 128 illustrations. Index. 352pp. 5⅜ × 8½.
25664-2 Pa. $8.95

ENGINEERING IN HISTORY, Richard Shelton Kirby, et al. Broad, nontechnical survey of history's major technological advances: birth of Greek science, industrial revolution, electricity and applied science, 20th-century automation, much more. 181 illustrations. ". . . excellent . . ."—Isis. Bibliography. vii + 530pp. 5⅜ × 8¼.
26412-2 Pa. $14.95